IMAGES
of America

SUMMERVILLE

ON THE COVER: The Summerville High School Band—under the direction of the school's first band director, Frank deParle—marched on North Main Street towards Town Square in support of the Green Wave football team during the 1954 homecoming parade. (Summerville Dorchester Museum.)

IMAGES
of America

SUMMERVILLE

Jerry Crotty and Margaret Ann Michels

ARCADIA
PUBLISHING

Published by Arcadia Publishing
Charleston, South Carolina

Printed in the United States of America

Library of Congress Control Number: 2010937381

For all general information, please contact Arcadia Publishing:
Telephone 843-853-2070
Fax 843-853-0044
E-mail sales@arcadiapublishing.com
For customer service and orders:
Toll-Free 1-888-313-2665

Visit us on the Internet at www.arcadiapublishing.com

*Dedicated to those who shared their memories, experiences, and insights,
allowing us to better understand and appreciate the
history and the beauty of Summerville.*

CONTENTS

ACKNOWLEDGMENTS

These organizations and Summerville residents—both past and present—graciously allowed us to use their photographs, memorabilia, and memories for this little book: Robert E. Anderson, Davie Beard, Sissue Boyle Beauchene, Dan Bell, Jane Boyle Brown, Judy Burn, Joe Cicero, Mildred Giet, Sylvia and Benjamin D. Godfrey, Barbara Lynch Hill, Mike Hinson, Josephine D. Hoffses, Heyward Hutson, Alexander McIntosh, Marie McLeod, Joan and John McKissick, Stephanie Mitchum, Marlena and Berlin G. Myers, Chris Ohm, Barbara Millen Patrick, Margaret Luke Pollack, Dora Ann Reaves, Joanne Saylor, Peter and Linda Shelbourne, E. M. Strobel, Helen Anderson Waring Tovey, Jimmy Waring, Dr. Ed West, Susanne Williams, Mark Woodard, *Carolina Homes & Interiors*, the Charleston County Library–South Carolina History Room, Dorchester County Library, *Dorchester Eagle-Record*, Drayton Hall, D.R.E.A.M., Flowertown Players, Greater Summerville/Dorchester County Chamber of Commerce, ILoveSummerville.com, MySCHistory. com, Photographix, Sculpture in the South, South Carolina Department of Archives and History, Summerville Baptist Church, Summerville Community Orchestra, Summerville Dorchester Museum, *Summerville Journal Scene*, Summerville Preservation Society, Timrod Library, *Welcome to Summerville,* and Woodlands Inn. We are forever grateful for their time and their insight. For those not listed here who spent a few moments or a few hours with us sharing what they know about Summerville, we thank you as well. Thank you to the rest of our team who tracked down information or photographs and provided their support in other ways: Ashton Cobb, Michael D. Coker, and Charmaine Wozniak. To the folks at the Single Smile Café, Sweetwater Cafe, the Summer House, and Atlanta Bread Company in Summerville who allowed us to spread out our research, conduct meetings, and take up a table in their establishments; we appreciate your patience and your coffee. To Lindsay Carter, Maggie Bullwinkel, and the Arcadia Publishing team for all they did to make this book happen and to make it better. And finally, we thank Elizabeth, Kathleen, Patrick, Joe, Conner, and our friends and families for lending their support as we spent countless hours away from them in our pursuit of history, but especially for listening during the countless hours we spent with them talking about it.

INTRODUCTION

It is hard to find a written history of Summerville that does not begin with an acknowledgement that much is missing. Legaré Walker's 1910 *A Sketch of the Town of Summerville, South Carolina* opens with the admission, "So far as is known, there is no complete, connected, and full history of the Town of Summerville." He goes on to offer "a more-or-less connected narrative," with all the facts and references he could gather, and a hope that they would be preserved to help future chroniclers in their research for the compilation of a more complete history.

South Carolina Department of Parks, Recreation, and Tourism historian Daniel J. Bell started his 1995 visitor's guide to the Old Dorchester State Park with the same lament, quoting an anonymous antebellum author: "There may be, and we have no doubt there are, many well substantiated traditions concerning the place, existing in some of our oldest families, which have never been given to the public: and we sincerely trust, that the very meagerness of the present article may have the effect of bringing to light these traditions." The photographs and stories in this book are intended to do the same—to inspire others to bring their own history of Summerville to light, to discuss it, to share it, and to record it for the future. These pages tell just a small part of the story.

Summerville was incorporated in 1847. A town hall was built, regular mail service started, and a commuter train brought business people and professionals back and forth to Charleston. Though it sacrificed its share of men, Summerville dodged the physical destruction of the Civil War.

Reconstruction was as brutal and difficult here as it was anywhere else in the South. However, the town's recovery and restoration were well underway by 1887 when, at a Paris convention of physicians, it was declared that Summerville, South Carolina, was one of the two most healthful places in the world for people suffering with respiratory problems.

That announcement brought Summerville to the attention of investors and visitors looking for a quiet, small town near the advantages of a larger city like Charleston. A kind of golden age followed. Inns and the tourists they attracted provided jobs, as did an ambitious and generally successful effort to commercially produce American tea.

The First World War claimed only one of Summerville's citizens, but the Depression and the Second World War followed to alter lives here as they did everywhere. Much of the tourism trade was lost to locations farther south as the railroad age ended and the Interstate Highway system arrived. Expansion of the Charleston Navy Yard and the opening of the Charleston Air Force Base fueled a need for more homes, and developers eyed the uninhabited expanses around Summerville with enthusiasm.

The magnitude and speed of change in the later 20th century could have consumed Summerville entirely but for the commitment to historic preservation fueled by a small number of residents. In 1972, the Summerville Preservation Society was founded. In 1973, their efforts resulted in the historic downtown area being included in the Inventory of Historic Places in South Carolina. In 1976, it was listed on the National Register of Historic Places. The restoration of the town's

Azalea Park began in 1976 and continued for over 10 years. In 1981, Summerville was designated a Tree City USA. The Summerville Dorchester Museum was organized in 1991.

In 1997, the celebration of the town's sesquicentennial solidified a commitment to preserving its heritage and history. Summerville D.R.E.A.M. (Downtown Restoration, Enhancement, and Management) was later formed with the purpose of "preserving the past, promoting the present, and protecting the future of Downtown Summerville."

Summerville's history may seem safely protected but—as the authors discovered while compiling this tiny snapshot of the town's past—there is much more to know. Many more photographs, stories, anecdotes, and personal histories remain to be recorded and shared.

The time must come wherein thou shalt be taught
The value and the beauty of the Past.
—excerpt from "The Past" by Henry Timrod

KEY TO PHOTOGRAPHIC CONTRIBUTORS
Robert E. Anderson—REA
Davie Beard—DB
Sissue Boyle Beauchene and Jane Boyle Brown—SJB
Michael D. Coker—MDC
Jerry Crotty—JC
Days of Dorchester—DD
Drayton Hall—DH
D.R.E.A.M.—DRM
Flowertown Players—FP
Mildred Giet—MG
Sylvia and Benjamin D. Godfrey—SBG
Josephine D. Hoffses—JDH
Library of Congress—LOC
Margaret Luke Pollack—MLP
Marie McLeod—McL
Alexander McIntosh—AM
Joan and John McKissick—McK
Media Services—MS
Marlena Myers—MM
Margaret Ann Michels—MAM
Gus Moody—GM
Peter and Linda Shelbourne—PLS
E. M. Strobel—EMS
Sculpture in the South—SS
SC Department of Archives and History—SCA
Summerville Baptist Church—SBC
Summerville Community Orchestra—SCO
Summerville Dorchester Museum—SDM
The Summer House—SH
Timrod Library—TIM
Helen Anderson Waring Tovey—HAT
Jimmy Waring—JW
Woodlands Inn—WI
U.S. Geological Survey—USG

One

THE ORIGINS

What is known now as Summerville traces its origins to the banks of the upper Ashley River, when, in 1697, a group of Congregationalists moved from Dorchester, Massachusetts, to the South Carolina Lowcountry to "settle the gospel" and establish a village. They called it Dorchester after their northern home and the town in England where their denomination had been founded. By building wharves, a house of worship, and a free school—and by establishing a place of trade to serve the outlying plantations and farms—they shaped the future of the area. A fort was built to provide defense, and while the town persisted, it apparently never prospered. Records show that in 1708, Dorchester was home to 305 souls. In 1741, 468 whites and 3,347 slaves were counted. However, by 1761, the Congregationalists had moved on to a new settlement in Midway, Georgia. In the 1780s, British troops occupied the apparently deserted town.

There is no definitive explanation for why the town was abandoned. Daniel J. Bell begins his *Visitor's Guide to the Old Dorchester Historic Site* admitting "much about Dorchester remains unknown." However, records show that during the mid-18th century, some of its residents relocated farther inland. During the summer months, the plantations served by Dorchester had proven to be uncomfortably hot with a proliferation of mosquitoes believed to carry disease. In his 2006 book, *Plantations, Pineland Villages, Pinopolis and Its People*, Dr. Norman Sinkler Walsh references death and disease to explain why settlers seasonally left the lowland swamps and river-bottom rice fields for sandy ridges and woods where pine trees grew. "The plantation was a delightful place to live. Its residents would not have subjected themselves to the semiannual move from plantation to pineland village, unless their lives depended on it." Summerville, located on a pineland ridge, was one of the seasonal camps inhabited by Lowcountry residents during the dangerous summer fever season. Gradually, many made Summerville their permanent home.

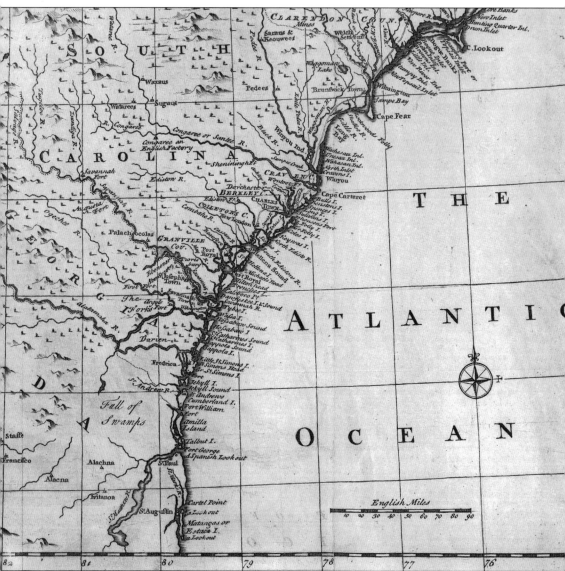

This is part of a 1752 map published in London as "a new & accurate map of the provinces of North & South Carolina, Georgia &c." created from the latest land surveys and observances by Emanuel Bowen. It shows Dorchester on the Ashley River about 18 miles west of Charles Town [sic] (between vertical lines 78 and 79, just above horizontal line 33) in what was then known as Berkley County [sic], South Carolina. A large number of Native American place names appear on the early map. There were relatively few English settlements. (LOC.)

This 1875 drawing depicts the Old White Meeting House built near the town of Dorchester for worship services by the settlers soon after their arrival. Though the plaster-over-brick finish may have been white in color, its name is more likely for Rev. John White, patriarch of Dorchester, England, and one of the chief founders of the Massachusetts Colony. The Old White Meeting House was renovated and rebuilt several times before the 1886 earthquake destroyed it. (DD.)

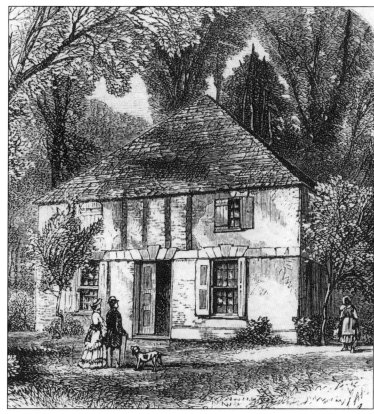

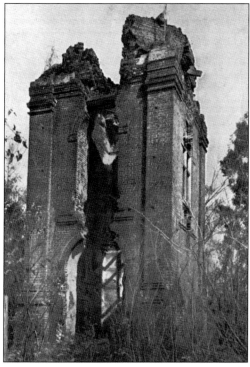

By 1736, several more churches served Dorchester and the area around it. Though the Lords Proprietors lured settlers to Carolina with promises of religious tolerance, by 1707 the Church of England was firmly established as the prominent church of the colony, which had been divided into Anglican parishes—including Dorchester, where this St. George's church structure was built in 1719. The belfry was added in 1751 to create what one visitor described as "a very handsome Brick Church with a Steeple, 4 bells and an organ." (DB.)

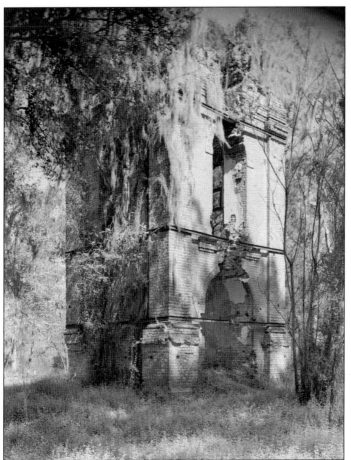

British soldiers are rumored to have butchered meat in the cemetery at St. George's, leaving marks on gravestones still visible today. The soldiers burned the church when their occupation ended in 1781. A 1788 record by Methodist bishop Francis Asbury indicates the church was in ruins. The brick walls were scavenged, and by the mid-1800s, only the tower remained. The 1886 earthquake split the tower and destroyed its remaining octagonal cap. The straps shown in this 1940 C. O. Greene photograph (part of a Historic American Buildings Survey) were installed around the tower to stabilize it and prevent further damage. (LOC.)

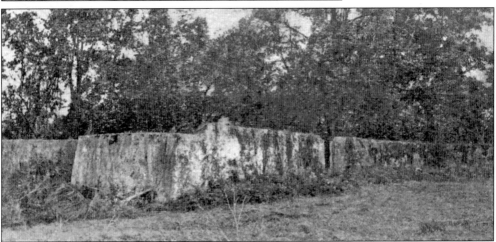

The walls of Fort Dorchester were completed around 1760 to protect a brick powder magazine. Munitions were stored here in case the English needed to defend the interior of the colony against French, Spanish, or Native American attackers. Still standing on a bluff above the Ashley River, the 8-foot-high, 2-foot-thick walls were made of tabby, a strong mixture of shells, sand, and lime created by burning oyster shells. (DB.)

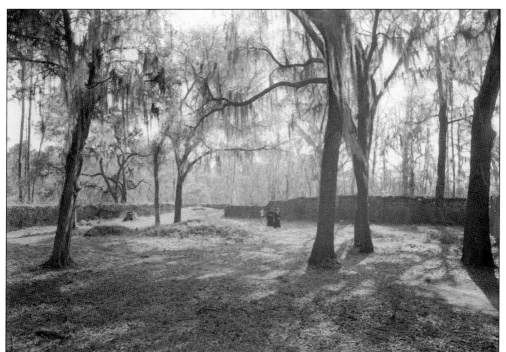

The fort walls formed a 100-foot square around the brick powder magazine, which was partly buried to minimize danger in case of an explosion. Ingredients for tabby were widely available, and the mixture did not require skilled brick masons. Fort Dorchester still stands and is remarkably well preserved. A missing wall may have been removed to allow wagons inside to salvage bricks. This photograph was also taken as part of the Historic American Buildings Survey in 1940. (LOC.)

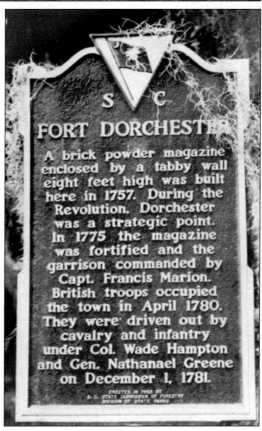

SC

FORT DORCHESTER

A brick powder magazine enclosed by a tabby wall eight feet high was built here in 1757. During the Revolution, Dorchester was a strategic point. In 1775 the magazine was fortified and the garrison commanded by Capt. Francis Marion. British troops occupied the town in April 1780. They were driven out by cavalry and infantry under Col. Wade Hampton and Gen. Nathanael Greene on December 1, 1781.

ERECTED IN 1969 BY
S. C. STATE COMMISSION OF FORESTRY
DIVISION OF STATE PARKS

While Patriots prepared the fort for use in 1775 as a place of refuge in case Charleston was captured by the British, it was mainly used as an armory and gathering point for militia. Storehouses were converted into barracks for the gathering troops, and locals were authorized to conscript slaves, horses, wagons, or whatever was needed to defend the colonists from the British. In 1780, the fort was occupied by the British who had previously captured Charleston. (DD.)

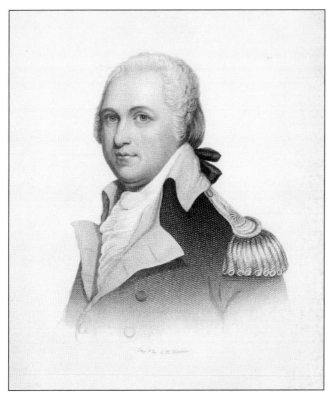

Continental colonel Henry "Lighthorse Harry" Lee (left) frequented the area, aiding the legendary "Swamp Fox," Francis Marion, in his efforts to interrupt the supply lines that Cornwallis relied upon as he moved his army inland from English-occupied Charleston. In the summer of 1781, Lee and his Patriot cavalry raided the fort, taking horses, wagons, and ammunition to benefit the Americans' ongoing hit-and-run guerilla campaign against the British. (MDC.)

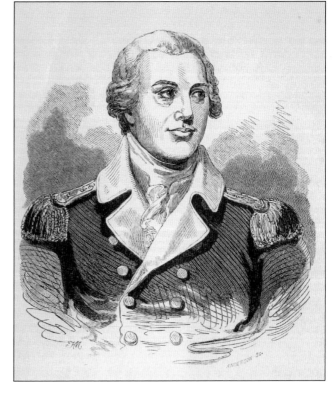

In December 1781, American general Nathanael Greene (right) planned to attack the British-occupied fort. The British learned of the plan and sent out a patrol. Col. Wade Hampton's cavalry advance met them and forced them back to the fort. Believing all of the attacking Patriot troops had arrived, the larger British force destroyed their remaining supplies and retreated to Charleston. (MDC.)

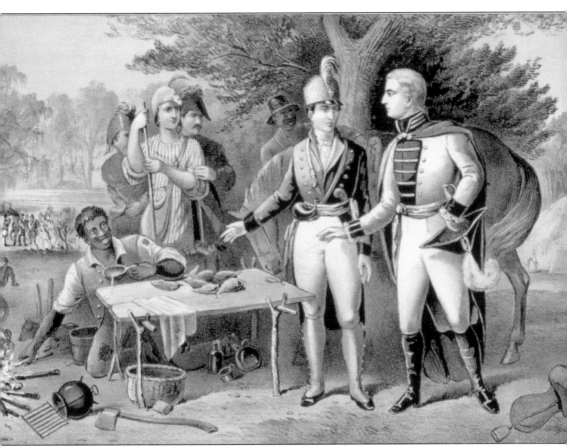

A photograph of a grand oak tree appears in *Points of Colonial Interest Around Summerville,* a 1905 Summerville souvenir booklet by Anne Simons Deas. Deas states that the tree is possibly "Marion's Oak" and suggests it was the site where Francis Marion and his men treated a young British officer to a legendary sweet potato banquet. This *c.* 1876 Currier and Ives lithograph illustrates the meeting. Sweet potatoes cooked by varied methods were offered to the British officer on pieces of pine bark, causing the Englishman to ask if the American soldiers regularly ate this. Marion replied, "Yes, and we are glad to get it." At that, the officer concluded that it was useless to try to conquer men who could live and fight so cheerfully on such meager fare. (LOC.)

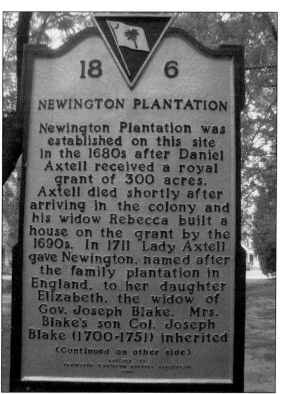

This historical marker indicates the site of what was reportedly one of the most beautiful plantations in the area. Newington's ruins stood for some time after it was abandoned—until the walls were removed in 1876 for the bricks. One story told about the decaying site says hunters seeking cover from the rain found old bottles of Madeira wine stashed behind a wall in the ruins. In her 1860 book *Days of Yore*, Elizabeth Poyas describes Newington, noting that its rooms were elegantly furnished with dark walnut. Its gardens and grounds were often counted among the most attractive in the state, and most descriptions mention the 100 windows on its front side and the stately avenue of oaks. (Both JC.)

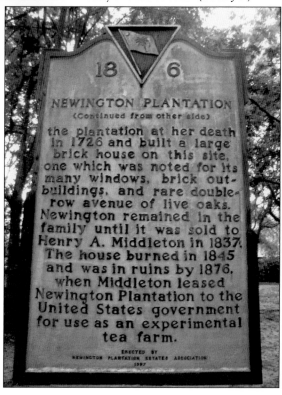

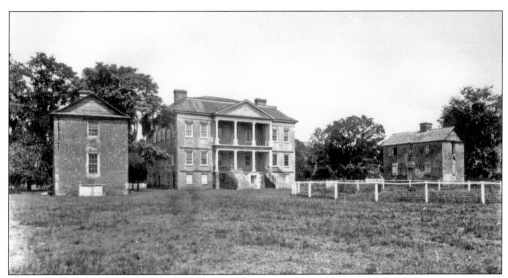

Drayton Hall (seen above after the Civil War), Middleton Plantation, and Magnolia Gardens are among the area's surviving plantations from the antebellum period. However, the modern day names of schools, neighborhoods, and roads testify to others: Archdale, Beech, Crowfield, Fairlawn, Mount Boone, Oak Forest, and Tranquil Hill. A historic site of the National Trust for Historic Preservation, today's Drayton Hall (below) provides a sense of the scale of the plantations that dominated the Lowcountry economy and countryside. Besides the naval stores, lumber, deerskin, and farm products that were traded, a plantation's enslaved labor force produced large crops of indigo and rice for export. Over 265 years after it was built, Drayton Hall's main house remains in near-original condition. Its stories of culture, race, family, sacrifice, and innovation reveal the history of the plantation era. (Both courtesy of Drayton Hall; below, photograph by Charlotte Caldwell.)

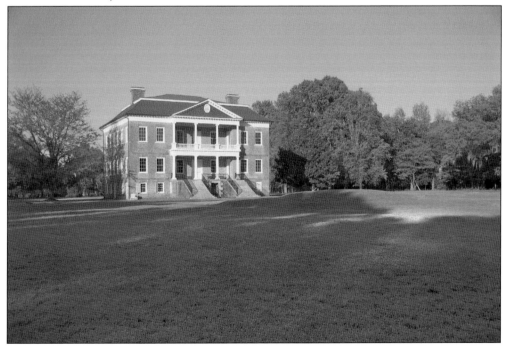

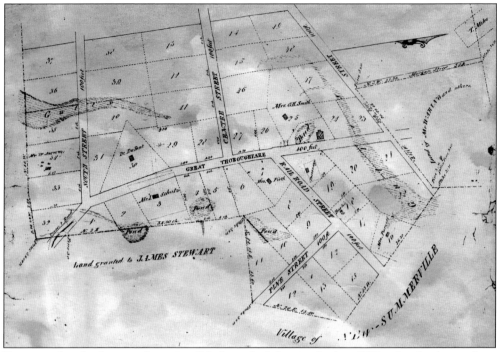

For over a hundred years, plantation life flourished, but in the late 1700s, the death rate from malaria increased, prompting planters to build camps—and then summer homes—among the pines on Summerville's sandy ridge to escape the swampy low lands. This 1831 plat of the area west of today's downtown shows some of the first streets in what was referred to even then as "old Summerville." The Great Thoroughfare is today's Carolina Avenue. (JW.)

Since the first sawmill began operating near Summerville—reportedly around 1699 in the area known as Saw Mill Branch—the timber industry has contributed heavily to the local economy. The abundance of unpopulated, well-drained woodlands, available labor, and the railroad combined to attract timber companies. Forestry, lumber production, processing, and distribution of wood for building materials, naval stores, or paper production seems to have always provided employment for area residents. (MDC.)

Two

EARLY SUMMERVILLE

Descriptions of antebellum Summerville are charming and involve narrow roads winding around tall trees and connecting yards where fires flickered and illuminated neighbors gathering on the broad porches of their rustic homes.

In time, apparently tiring of the back-and-forth moves and encouraged by the sociability of the closer quarters, Summerville's "marooners"—those setting up temporary homes to escape the summer heat, mosquitos, and accompanying diseases of their Lowcountry lands—began creating progressively more permanent structures. So many of his parishioners lived in Summerville that the St. George rector scheduled regular summer services in the village and erected a chapel that later became St. Paul's, Summerville's first church.

The South Carolina Canal and Railroad Company was founded by the state legislature in 1827 at the urging of Charleston merchants who were experiencing a decline in business due to the increased population and commerce inland, and the increased shipping traffic diverted to Savannah. The arrival of the first locomotive in 1830 and the completion of the line from Charleston to Hamburg in 1833 were milestones in railroad history. Until the arrival of the railroad, transportation was reliant on the weather. Roads traveled by foot, horseback, or coach could be dry and dusty—or wet and muddy. Navigation of the inland waterways relied on tides and rainfall. The railroad changed the method and frequency of travel. It also changed the locations where people lived.

Proximity to a railway line became important for commercial success as well as for pleasure travel. The South Carolina Canal and Railroad Company purchased 1,800 acres of land near Summerville to supply timber for the railroad. Near the rail line, the company laid out a planned town with streets running at right angles from the tracks. The town plan included 200 one-acre plats; most were sold at a public auction in 1831. Summerville grew from there.

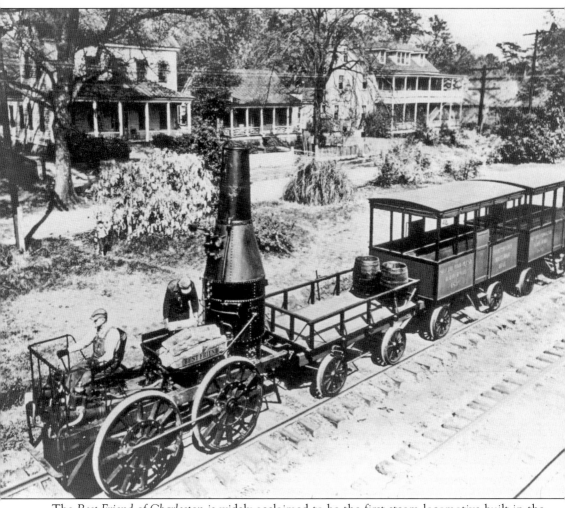

The *Best Friend of Charleston* is widely acclaimed to be the first steam locomotive built in the United States, the first with regularly scheduled passenger service, and the first to carry U.S. mail. The *Charleston Courier* reported that its inaugural trip was on Christmas Day 1830. Passengers "flew on the wings of wind at the speed of 15 to 25 miles per hour, annihilating time and space . . . leaving all the world behind." The original *Best Friend* only operated for a short time; the boiler exploded six months after its inaugural run due to operator error. By then, a second locomotive had arrived and was operating on the newly laid line to Woodstock—a point between Charleston and Summerville east of Ladson. In 1832, the line to Summerville was complete. The *Best Friend of Charleston* shown here—passing through Summerville with Luke Street in the background—is a replica constructed from the original 1828 plans to commemorate the 100th anniversary of the South Carolina Canal and Railroad Company. The replica was donated to the City of Charleston by Norfolk Southern in 1993. (SH.)

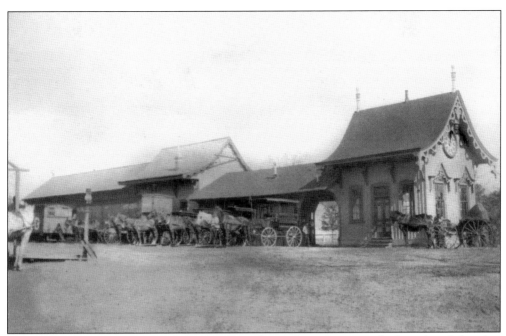

Activity around the Summerville depot offers a clue to the prominent role the railroad played in the town's early days. This first station was built around 1850 and torn down around 1910 to make room for the new Southern Railway Station. The cost of a ticket from Summerville to Charleston was 75¢. Trains ran from 6:00 a.m. to 6:00 p.m. except on Sundays. By the mid-1880s, trains were making the 40-minute trip five times a day. (REA.)

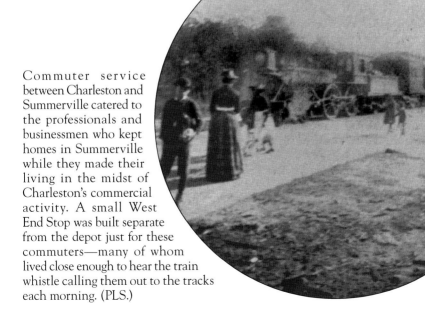

Commuter service between Charleston and Summerville catered to the professionals and businessmen who kept homes in Summerville while they made their living in the midst of Charleston's commercial activity. A small West End Stop was built separate from the depot just for these commuters—many of whom lived close enough to hear the train whistle calling them out to the tracks each morning. (PLS.)

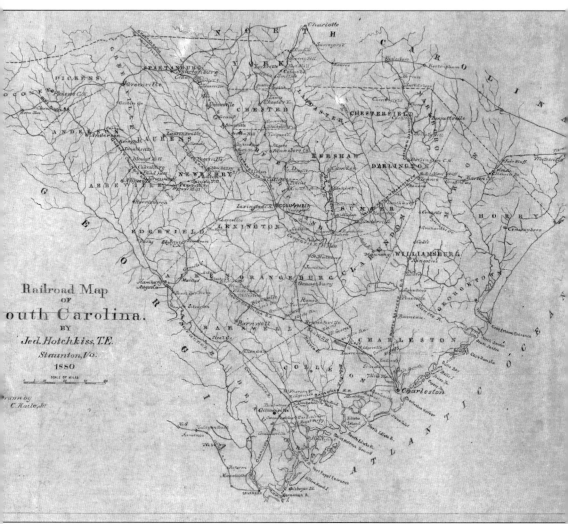

As this 1880 map shows, the South Carolina Railroad line between Summerville and Charleston was only one of many lines that were changing the landscape, economy, and culture of South Carolina. Summerville's multiple daily mail deliveries, telegraph station, and its connection to that larger railway network—particularly the lines that delivered the growing number of tourists from the North—was critical to the health of the town's economy and its place in the changing world. Look for Summerville beneath the "R" in the label for Charleston County. The Summerville tracks extended to Hamburg on the initial route. Hamburg was later connected to Columbia with another line. (LOC.)

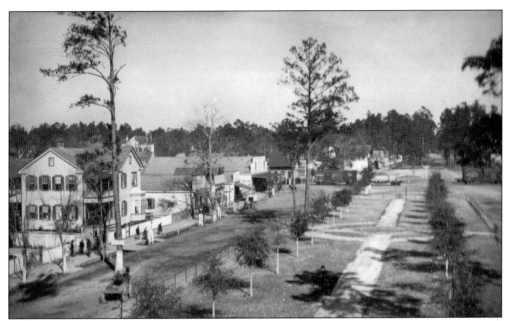

This view of Summerville's commercial district around 1880 shows its streets were not yet paved, horses and carriages still provided local transportation, and the new train depot was not built—the first station can be seen at the far end of the block before the railroad tracks. The buildings along the west side of Main Street were still wooden structures. (REA.)

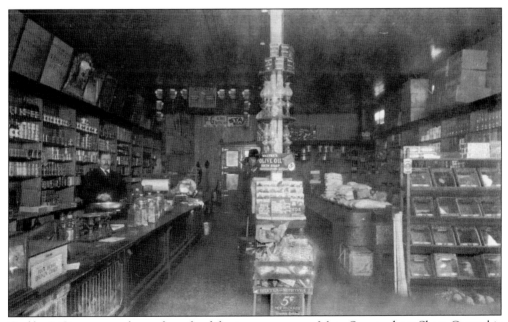

Godfrey's Grocery was located south of the town square on Main Street where Short Central is now. It was on the first floor of a two-story, V-shaped building that fit the footprint between two streets; the family lived upstairs. Benjamin Hayden Godfrey, the proprietor, stands behind the counter to the left. The two men in the center of the photograph are unidentified. (SBG.)

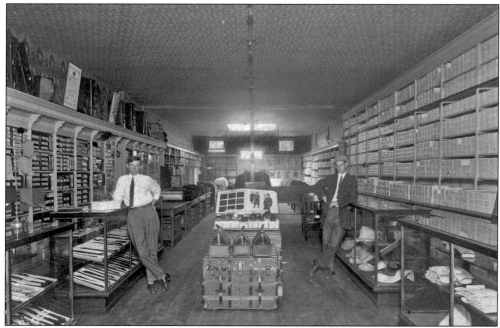

Saul Alexander (left) was an immigrant who came to Summerville in about 1904, initially working for Mirmow Dry Goods. Within 10 years, he was the proprietor of Alexander Dry Goods at West Main Street and Doty Avenue. Alexander is remembered as a kind, quiet man who was quick to help others in need. He left a large portion of his estate to the Saul Alexander Foundation. The trust income is spent on charitable deeds in Summerville and the Charleston area. (SBG.)

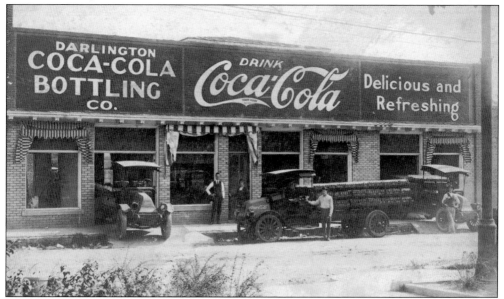

Darlington Coca-Cola Bottling Company was located on Cedar Street where the YMCA is now. The plant opened in 1915 and continued as a family business until it sold to Sunbelt in 1985. D. D. Bolen and Mildred Compton Salisbury were two of the owners. The back of the building opened onto a residential street; children gathered there to watch the conveyor belt feed bottles into the filling machine. (SBG.)

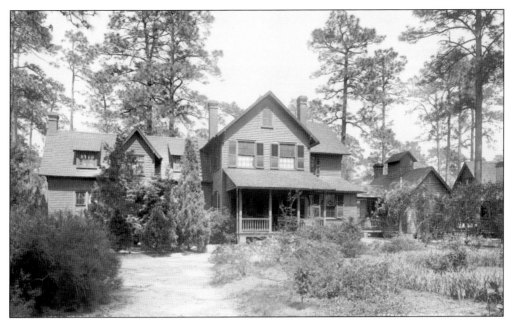

Tea farming in Summerville is traced to Andre Micheaux who brought plants to the land he purchased from the Middleton family at the end of the 18th century. The U.S. Department of Agriculture leased about 20 acres of his property for the experimental growth of tea plants, but the project was abandoned. Dr. Charles Upham Shepard, a chemist in Charleston, became interested in the idea and purchased about 500 acres from Middleton Plantation. He cultivated 100 acres with tea and also created beautiful flower gardens. One of the buildings he constructed on the subsequently named Pinehurst Tea Farm is shown here. (LOC.)

Shepard faced a challenge in bringing his tea to market. Due to much higher wages, it was estimated to cost him about eight times as much to pick tea in South Carolina as his competitors paid in Asia. Shepard solved this problem by opening a school for African American children and offering them education in exchange for picking tea during the harvest period. (LOC.)

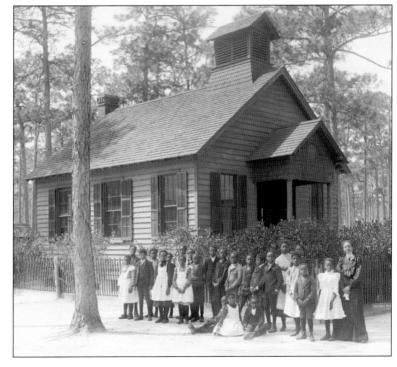

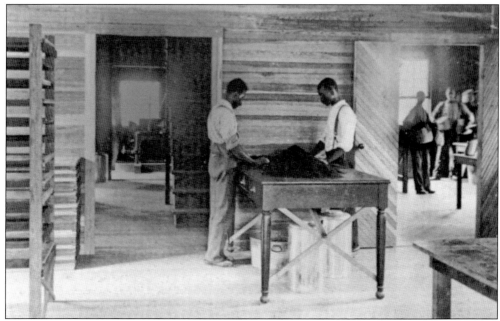

The tea farm drying and processing area is shown here. In a 1941 Dorchester County Historical Society brochure, Legaré Walker wrote that Shepard "designed and installed the necessary machinery for [tea] manufacture, and cultivated and manufactured tea of a high grade. He obtained a subsidy from the government, which showed much interest in the development of this industry in the hope that it might encourage others to engage in similar enterprises and thus a new industry might be generally established in this country." (DD.)

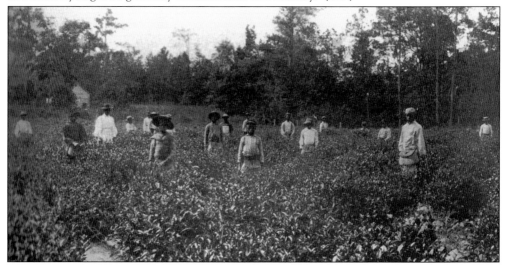

Shepard attracted attention for his product in 1904 at the St. Louis World's Fair when his oolong tea took first prize. The tea farm was also gaining attention from visitors to Summerville due to the grounds that Shepard cared for as much as he did the tea plants. They could tour the gardens, orchards, and groves of pecan trees or attend one of Shepard's "Talks on Tea." Shepard's farm thrived until his death in 1915. In 1960, Thomas J. Lipton purchased Pinehurst Tea Farm, rescued the surviving tea plants, and moved them to Wadmalaw Island where they now produce tea for the Charleston Tea Plantation. (TIM.)

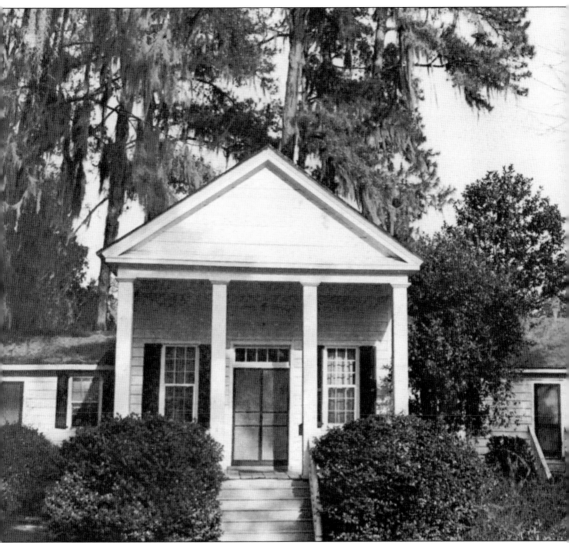

In the 1840s, Summerville's leading citizens were concerned about the town's future, given its rapid growth and the uncontrolled cutting of their famous pine trees. These inspired town leaders tried to determine a way to control—or at least have a say in—further development. In December 1847, they were granted the town's first charter. This is Summerville's old town hall and is located at 201 West Carolina Avenue. Used by the town from about 1860 to 1892, the building was saved and restored by the Summerville Preservation Society beginning with its purchase from the town in 1990. (DD.)

A town seal with the motto, "Sacra Pinus Estos" ("Let the Pine Be Sacred") was adopted, and this sentiment was reinforced with a tree ordinance in early 1848. No one could legally cut down or otherwise destroy a pine tree without the town council's permission—a $25 fine was established for violators. Almost a hundred years later, the *Charleston Evening Post* commented on the law: "Summerville, the Flower Town, is probably the safest place in the world to be these days—if you're a pine tree . . . A Summerville pine tree can jolly well stand around until it drops of old age about 90 per cent [*sic*] safe in the assurance that nobody will beginning chopping away on it." (DB.)

Three

GOLDEN ERA

The turn of the 19th century was a busy time in the history of Summerville: several major events in the town's history occurred between the 1880s and the 1920s. In 1886, the Great Charleston Earthquake rocked Summerville along with the rest of the South Carolina Lowcountry. The town enjoyed enormous attention when, in 1887, a group of international medical specialists meeting at a health summit in Paris declared Summerville to be one of the best places in the world to recuperate from respiratory problems. Charleston investors decided to capitalize on the announcement by developing a fine resort in Summerville. The luxurious Pine Forest Inn was the result. Summerville gained a reputation as a welcoming vacation destination for wealthy travelers. An influx of visitors from across the country and around the world followed. A variety of inns and hotels soon populated the little town. Summerville achieved additional international publicity when Pres. Theodore Roosevelt visited the village during his April 1902 trip to Charleston.

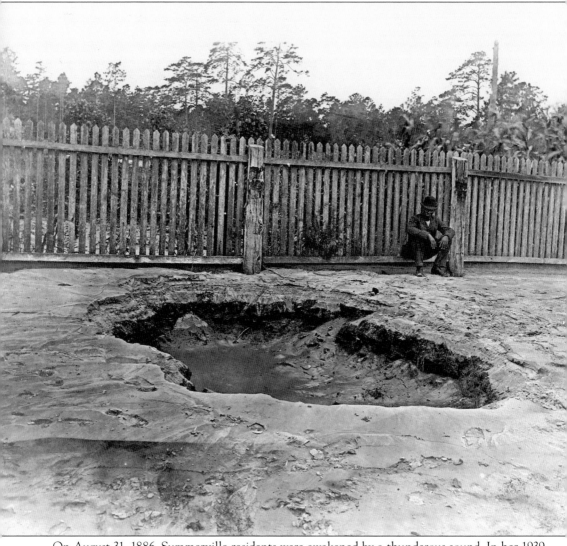

On August 31, 1886, Summerville residents were awakened by a thunderous sound. In her 1939 booklet *Summerville Past and Present*, Elizabeth M. Jamison reports, "At ten minutes of ten o'clock, without any warning, there was a rumble as of distant thunder and immediately the whole earth seemed to rise and fall, and quake and shake. Houses, chimneys, and walls caved in, houses shaken from their foundations fell carrying everything that could fall with them. The night became one of terror, at close intervals the earth would shake and rock. Everyone left their houses, fearful of staying in them, yet fearful of remaining outside. . . . At places along the roads water had boiled up from geysers and springs that had burst through the earth, and where sand had been earlier in the evening, was now running water several inches deep." Summerville had experienced a huge earthquake of about a 7.4 Richter scale magnitude. Although the epicenter seems to have been in Summerville, the more densely populated Charleston area sustained heavier damage and 60 deaths. Consequently, to this day, the event is known as the Great Charleston Earthquake. (USG.)

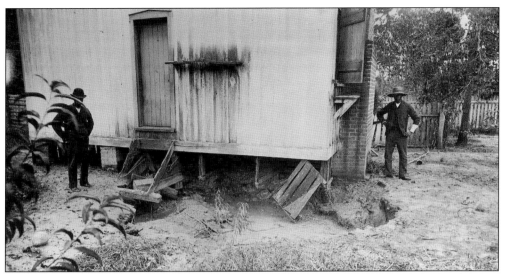

Residents have been retelling stories from the earthquake for years. One involves a chimney falling inside a house, creating a pile of bricks that separated a mother from her frightened children. Another tells of a mysterious stranger who saved the lives of passengers on the train to Charleston when he warned the stationmaster the tracks were out. The stationmaster signaled the train to stop before it reached the damaged tracks. Photographer C. C. Jones was sent by the U.S. Geological Survey to document the effects of the quake in Charleston. These depictions of the craters and foundation damage on Ten-Mile Hill are a small indication of the damage sustained in Summerville. Families lived in makeshift shelters and tents for weeks while repairing their homes. Some structures were too badly damaged to repair and eventually were torn down. (Both USG.)

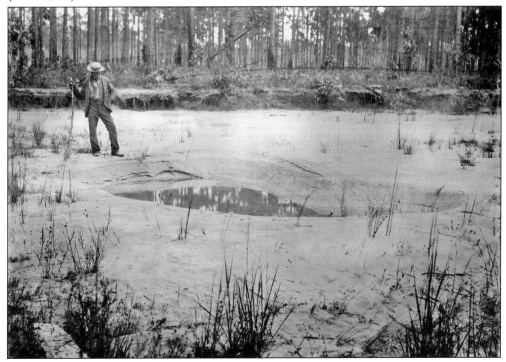

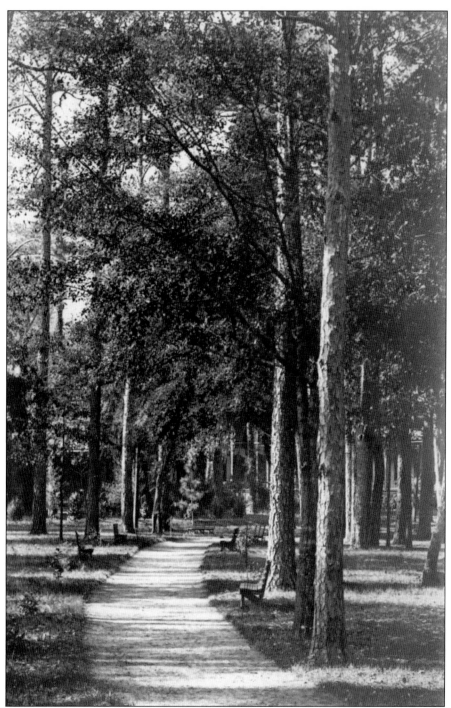

Earthquake damage in Charleston and Summerville was repaired. The railroad tracks were fixed and trains began running again. Summerville began enjoying the slow and steady economic development allowed by the normal growth pattern that train service was bringing to small towns all along the railway. Quiet times returned to the village in the pines. But soon they were interrupted again; this time by good news. (DB.)

In 1887, a medical world congress of respiratory specialists met in Paris. Known as the International Tuberculosis Congress, the group named Summerville one of the two best places in the world for the cure of lung disorders—thought to be helped by breathing the strong pine essence in the air. (The other location was Thomasville, Georgia.) (DB.)

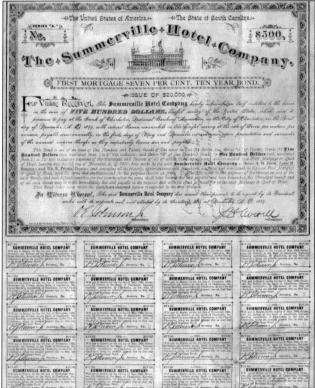

The Summerville Hotel Company sold bonds to raise funds to build a hotel. This one, valued at $500, was issued as a first year mortgage 7-percent, 10-year bond in 1889. Twenty $500 bonds and a hundred $100 bonds were issued in this series, a total of $20,000 in capital. When it opened in 1891, the hotel was named the Pine Forest Inn. (JW.)

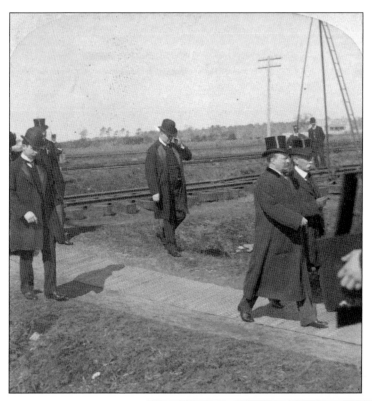

On April 8, 1902, Pres. Theodore Roosevelt attended the South Carolina Interstate and West Indian Exposition in Charleston. After visiting the expo and various Charleston attractions, the Roosevelts, Charleston mayor J. Adger Smyth, and their entourage arrived in Summerville by train. Roosevelt and Smyth (far right) were photographed strolling from the train depot along a carpet laid for their arrival. (LOC.)

President Roosevelt visited the Fort Dorchester ruins located south of Summerville. At the time, the photograph was labeled as a visit to the "old Spanish Fort." It is now known to be the ruins of the 1757 tabby fort built at Dorchester to provide a secondary location for munitions storage should Charleston fall in an attack by the French, Spanish, or Native Americans. (LOC.)

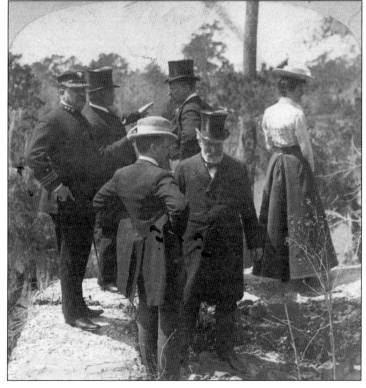

President Roosevelt also visited the Pinehurst Tea Farm. Dr. Charles U. Shepard began the farm on land he purchased from the Middleton estate. Shepard cultivated 100 acres in tea, built a tea factory, and marketed the first crop in 1892. He also opened a school for the African American children who picked the tea. The children entertained President Roosevelt during his visit to Pinehurst by singing for him. (Both LOC.)

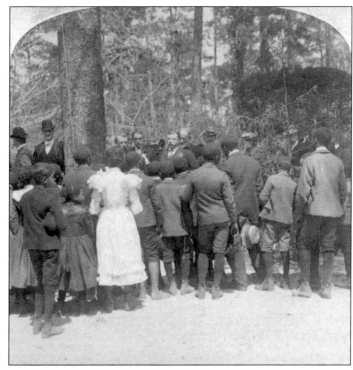

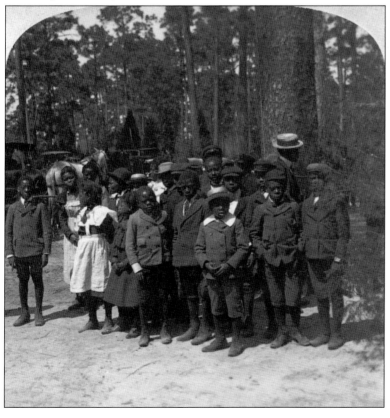

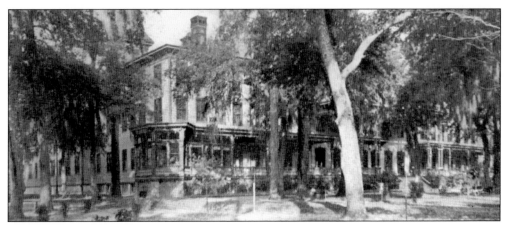

President Roosevelt, First Lady Edith Roosevelt, Mayor Smyth, U.S. Attorney General Philander C. Knox, cabinet secretaries James Wilson and George B. Cortelyou, and the rest of the visitors from Washington spent the night at the Pine Forest Inn as guests of Capt. F. W. Wagener, owner of the inn, president of the Exposition Company, and donor of the land used for the Charleston Exposition. (JW.)

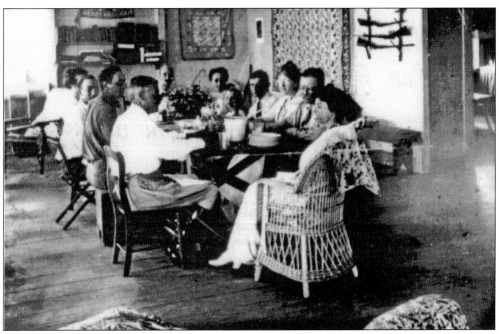

During their visit to the Pine Forest Inn, the Roosevelts enjoyed a casual meal with Captain Wagener and other guests in one of the dining rooms. The presidential party stayed just one night in Summerville—April 9, 1902—before returning by train to Washington, D.C. (SDM.)

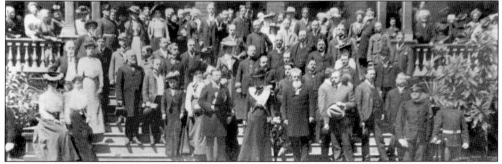

The president and his travel companions posed for a photograph on the grand front steps of the Pine Forest Inn before their departure on April 10, 1902. In the 1900s, a presidential visit was a major accomplishment for Summerville. Records show Pres. William Howard Taft was also a guest at the inn during his presidency. (JW.)

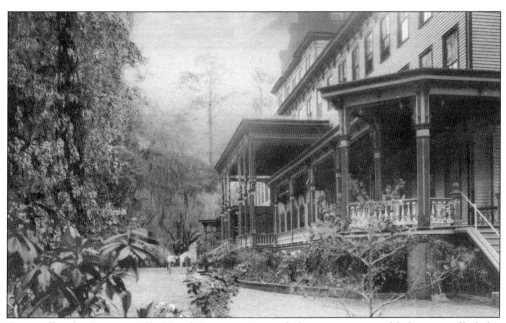

Originally, the Summerville Hotel Company intended to open an establishment called the Dorchester Inn. Reports of why that did not happen are vague, but the project was apparently taken over by Charleston investors F. W. Wagener and George A. Wagener. It was named the Pine Forest Inn and opened for guests in 1891. (DB.)

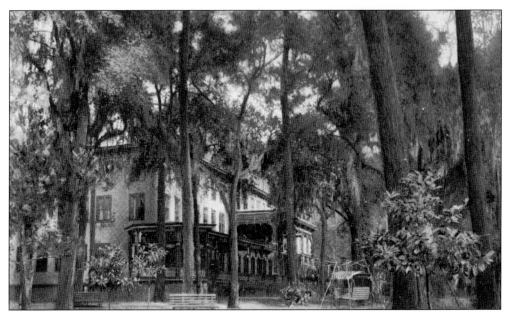

An advertisement for the Pine Forest Inn in a 1905 souvenir booklet of Summerville written by Anne Simons Deas called *Points of Colonial Interest Around Summerville* proclaimed the inn was, "Located in a beautiful park of 70 acres of pine forest. Up-to-date in all its appointments. Must be seen to be appreciated. Eighteen-hole golf course, tennis, bowling, saddle and driving horses." (DB.)

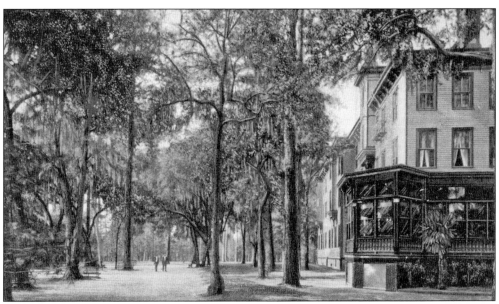

Incredibly tall pine trees covered the grounds around the Pine Forest Inn. Years later, when the area was being prepared for a residential subdivision, James B. Waring, spokesman for the developer, told reporters, "We dodged the trees when we built the road. The live oaks and magnolias were saved. All the lots are covered with azaleas and camellias, which once were gardens around the inn." (DB.)

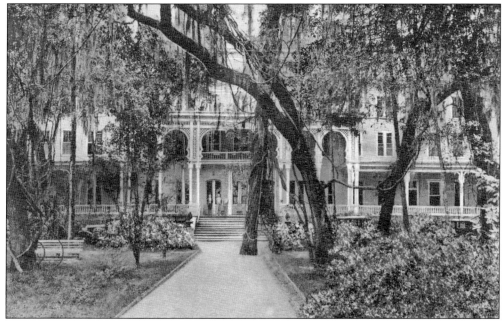

A long path led through the Pine Forest Inn gardens up to the entrance. The surrounding park—with its colorful azalea, camellias, and stately trees—made for a dramatic entrance. Around 1905, the room rate was $5 and upward per day. Weekly rates were available and varied according to room location. There were also cottages on the property available for rent. Each cottage included electricity, plumbing with hot and cold running water, and fireplaces. (DB.)

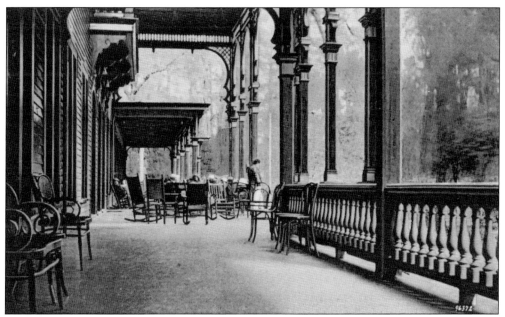

The impressive front piazza extended 185 feet in length and was 45 feet wide. It provided a welcome place for conversation, reading, taking afternoon tea, or simply enjoying the surrounding nature. The front entrance hall that ran through the center of the building was 47 feet long. There was a central rotunda on the ground floor and a lobby on each of the three floors. (DB.)

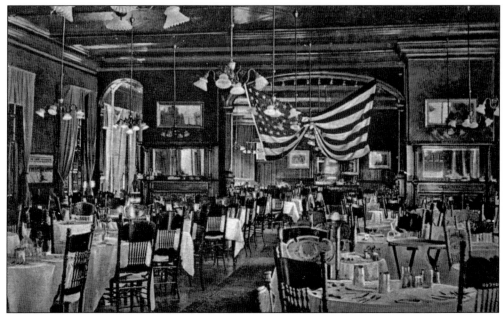

Containing 200 guest rooms, the three-story, rambling building had a large dining room and several smaller rooms for more intimate service. Measuring 38 feet wide and 69 feet long, the main dining room could accommodate 250 people at a seating. (DB.)

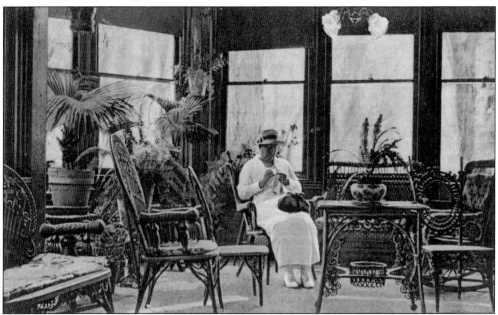

The sunroom was decorated with plants and furnished with comfortable chairs, benches, and rockers. The surrounding windows made it a bright location for doing needlework, but electricity was also available as it was in the entire facility—the inn had its own power plant. There are reports it also had a large parlor called "The Rocking Chair Room," furnished with over 100 rockers. (DB.)

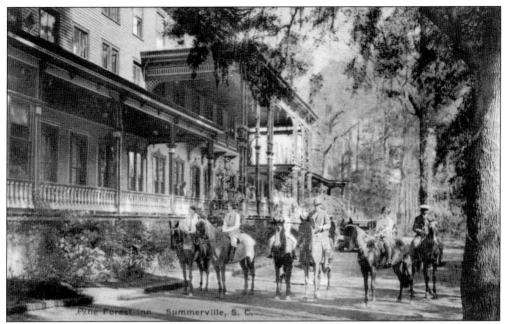

Arrangements were made for inn guests to use the grounds of the Ingleside plantation as hunting grounds. Located just 6 miles from the Pine Forest Inn, the 1,800 acres of shooting reserve provided ample deer, quail, turkey, rabbit, fox, and other small game. The inn could provide horses and foxhounds as needed. Ingleside also had a large fishing pond available to the guests. (DB.)

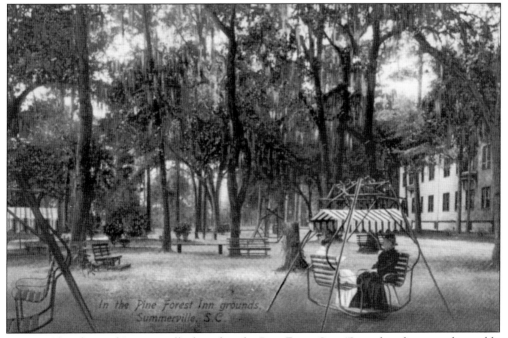

A c. 1905 brochure of Summerville describes the Pine Forest Inn: "It is a handsome and superbly constructed building, standing upon a plateau of 60 acres, beautifully wooded with pines interspersed with live oaks, from which the rainfall naturally flows into an adjacent creek, affording perfect drainage of the entire property and its surroundings." (DB.)

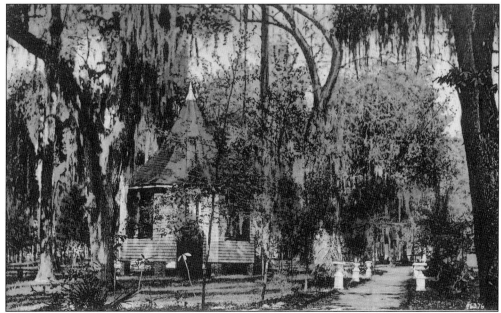

The sun house (above) was located in the park on the inn's grounds. There was also a building called the amusement hall that seems to have been a game room. An open area under the pines had been cleared for lawn games like croquet (below). The property also included a golf course and tennis courts. The Summerville brochure continues with its description: "It is a modern structure in every respect, and has all the latest improvements for comfort and convenience. The arrangement of rooms is such, that there are single rooms with or without private baths, as well as suites for family parties. The lighting is by an Edison-improved electric plant. The heating is amply secured by a combination of open fires, steam radiators, and the fan system of hot air; this latter also insuring perfect ventilation. Every sleeping room in the house has direct sunshine upon it during some portion of the day, and nearly every room has a fire-place [sic] for pine-knot open fire." (Both DB.)

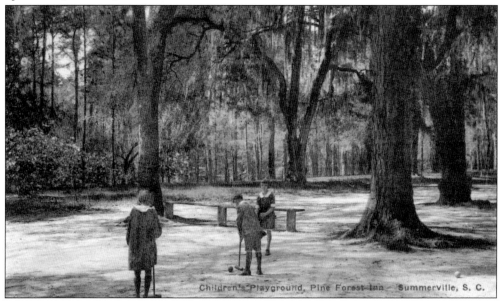

Children's Playground, Pine Forest Inn - Summerville, S. C.

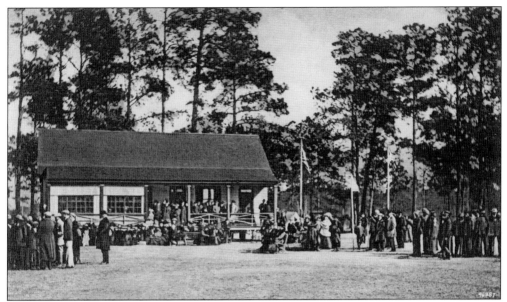

The golf course at the Pine Forest Inn is believed to be one of the earliest in the country and was reported in an inn brochure to have been designed by a golf professional "from the North who has played on the celebrated links of St. Andrews, Scotland." At the time, the 18-hole Pine Forest Inn course was described as unexcelled and one of the most beautiful in America. The accompanying clubhouse included locker rooms for both men and women and a reception room with fireplaces. (DB.)

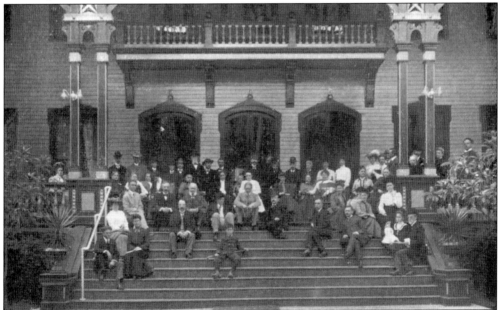

The Wageners visited luxury resorts to determine which features to adopt for their own. They included a library, a reading room, and a wine cellar. The walls were of rich pine paneling, the floors of polished heart-pine, and the high ceilings hung with chandeliers. Leather chairs, marble mantels, and log-burning fires completed the effect. Guests were encouraged to roam the property, take advantage of the amenities, and lounge in pine-scented luxury. (TIM.)

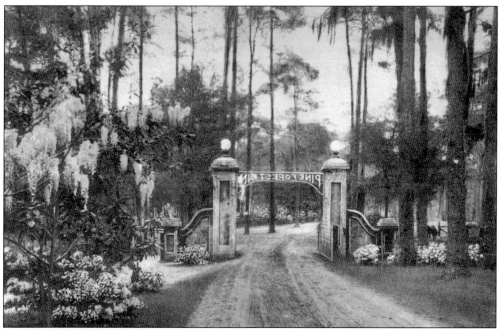

For over four decades, arriving and departing guests passed through these gates. Then the Great Depression came and occupancy at the Pine Forest Inn declined. T. W. Salisbury purchased it in 1939 and ran the inn for two years. After World War II, it was home to the Adventure Boarding School for a short time. Eventually the building fell into disrepair, and fearing a fire would destroy it, Salisbury disassembled what could be salvaged from the interior and the structure was demolished. In the 1970s, the remaining 24 acres were developed into an upscale residential neighborhood. The columns of this gateway and the remains of the gardens are the only lingering evidence of the Pine Forest Inn's location. (JDH.)

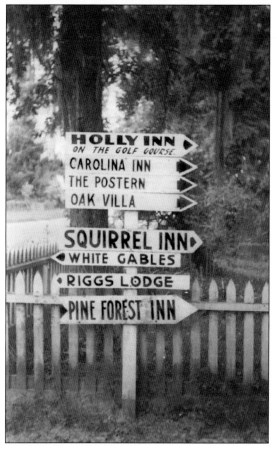

An old-fashioned direction sign names several of the lodging establishments in Summerville. Most of the inns were located in the area known as "old Summerville." Developed organically before the town plan of 1832, old Summerville is still distinguishable by its winding roads, old-growth pines, and historic homes. (SDM.)

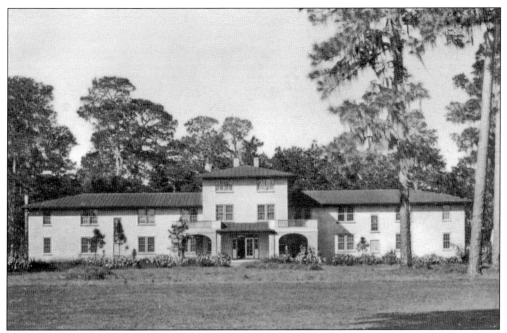

The Holly Inn was located on the grounds of the 1,100-acre Summerville Club and first opened as a gentlemen's club around 1910. Later it operated as an inn during the winter tourist season from November to May. Guests were able to play on the 18-hole golf course located right outside their door. (DB.)

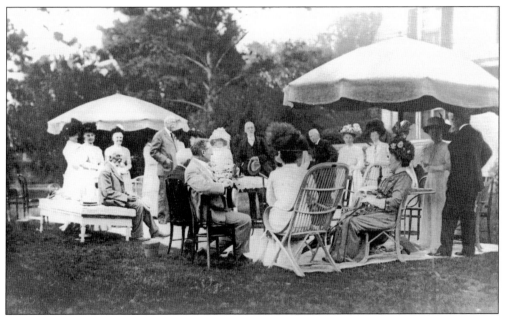

The mild climate was a major draw for travelers from points north, so outdoor dining was very popular at the Summerville inns. This c. 1900 photograph shows how a picnic might be held on the lawn, complete with a ground covering over the grass and umbrellas to provide shade. Notice the formal attire and the elaborate hats on the women. (MS.)

45

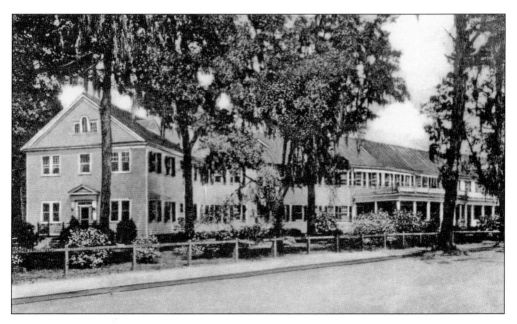

The Carolina Inn was located on West Carolina Avenue and Sumter Avenue. It was called the Summerville House when I. T. Brown owned it around 1855. It also operated as the Dorchester Inn for a short time. In 1912, when the Carolina Inn owners purchased the property, they enlarged the structure, extensively remodeled the interior, and modernized the building. Amenities even included a swimming pool. An advertisement from the time indicates the property also offered facility rentals and catering services. The 67-guest-room inn was open all year and had a refined ambiance, though not as luxurious as the Pine Forest Inn of the same era. (Above, MG; below, DB.)

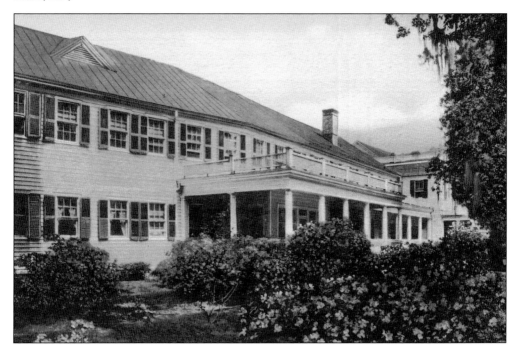

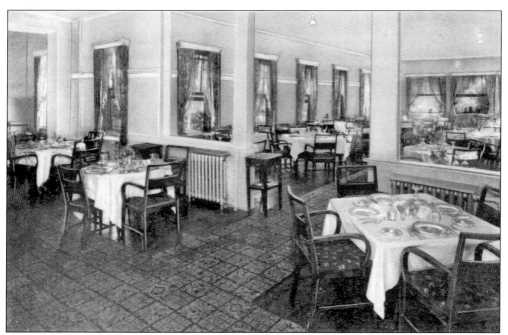

One of the more upscale establishments in Summerville, the Carolina Inn included a large, well-lit dining room with white tablecloths, china, sterling, and wonderful meals. A separate dining area was available for the employees of guests who accompanied them on their travels. (DB.)

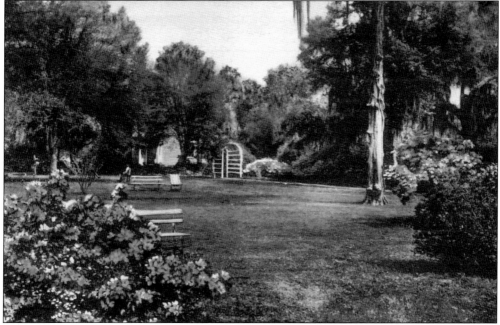

Like many of Summerville's inns, the Carolina Inn was surrounded by landscaped gardens and lawns available for the use of its guests. Unfortunately succumbing to the same economic conditions that ended the Pine Forest Inn, the Carolina Inn went into disrepair and was torn down in the 1960s. (DB.)

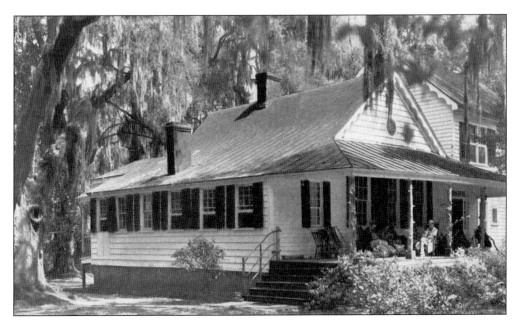

The Postern seems to have originated around 1818 as the Boone House—after owner T. W. Boone—where the Episcopal congregation reportedly held services during the 1820s before St. Paul's was built. In 1905, the Postern garden photograph (below) was used as an advertisement by C. C. Walker in a souvenir booklet for Summerville. Mrs. John B. Watkins placed an advertisement around 1927 in *Summerville, SC, The Flowertown in the Pines* describing the Postern as "a House not a Hotel, nestled in a famous old garden of camellias, asalias [sic] and Wisterias, surrounded by a forest of pines." Many years later, the foundation was all that remained, and a new home was constructed on the site. (Both DB.)

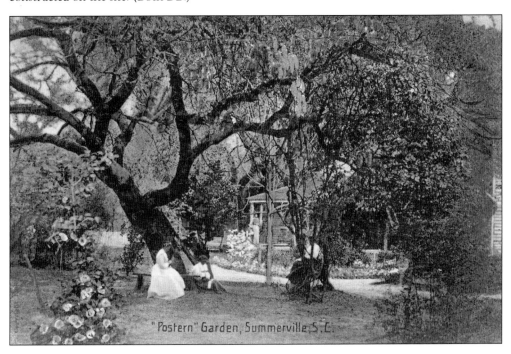

"Postern" Garden, Summerville, S. C.

Lottie Lee Fogle wore the popular fashion of the day when she had her portrait taken as a young woman around 1905. The Fogles were a prominent family in Summerville and may have enjoyed hospitality in the dining rooms at the local inns. Fogle later married David D. Bolen and was the mother of his seven daughters. (SBG.)

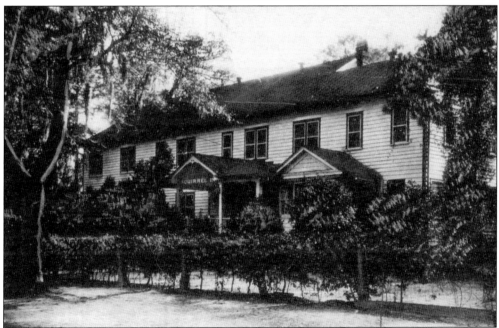

According to the Summerville Preservation Society's Trail of Home and Flowers self-guided walking tour, Raven Lewis established the Squirrel Inn. Other sources say her sister Helen was coproprietor. Originally opened around 1912, Jeanne and Eugene Sutter purchased the establishment in the mid-1940s and made it popular with their fine cuisine and wine cellar. The inn closed in 1970 and has since been renovated into condominiums. (DB.)

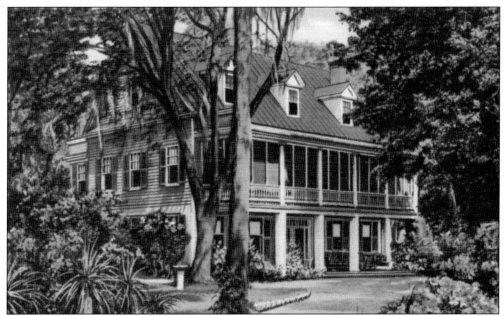

White Gables began as a private residence, morphed into a boardinghouse, and was turned into an inn by Sarah Woodruff as a way to ensure financial stability. (Her husband was known to gamble.) Woodruff ran the inn until 1939, when Mary Hutchinson McIntosh took over the establishment. In 1950, Bill and Beth McIntosh converted it back to a private residence for themselves and their three sons. Today another family calls White Gables home. (DB.)

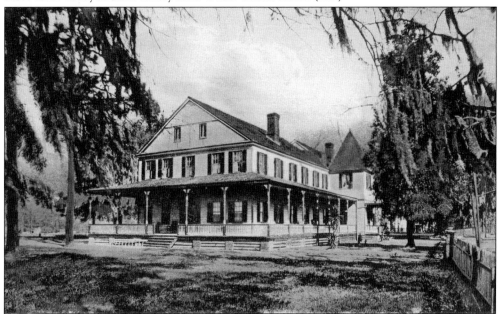

Prior to becoming the Dorchester Inn shown here, this property on Carolina Avenue was home to Brown's Hotel—also called Summerville House. Before that, around 1810, Moore's Tavern was located on the site. After the proprietor of Brown's Hotel died, it reopened around 1905 as the Dorchester Inn, operated by John R. MacDonald. Shortly after, the building underwent a major renovation and the Carolina Inn opened in this location. (DB.)

The Halcyon is yet another example of a Summerville home becoming a lodging establishment or the reverse. The Halcyon is now a private home, but at the height of the town's tourism boom, it operated as a guest house. (DB.)

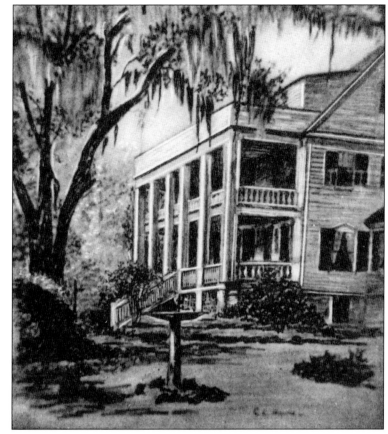

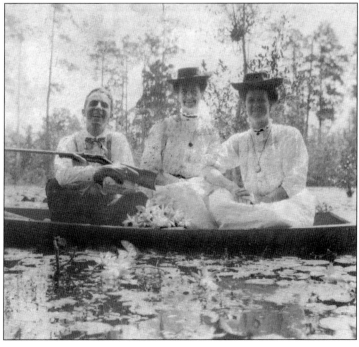

Boating, hunting, and picking flowers were typical amusements for visitors to Summerville during their stays at the inns. In this c. 1905 image, Summerville resident Joe Bolen, Aunt Maggie, and a friend have managed to combine all three activities. (SGB.)

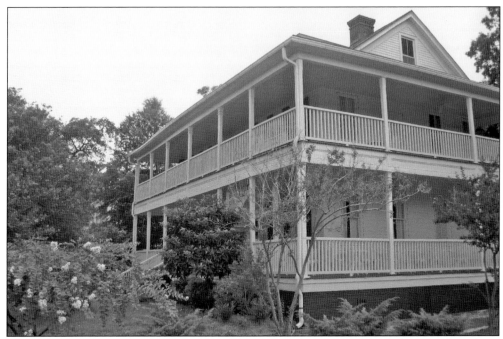

This three-story house on West Luke Street (formerly Railroad Avenue) is believed to have been built around 1890 for use as a boardinghouse. In the 1920s, it was called Traveler's Rest. Helen Anderson Waring Tovey remembers staying at Traveler's Rest with her mother and her younger twin siblings after they first moved to Summerville in 1926 when Helen was five. It is now called the Summer House and is available for private events. (JC.)

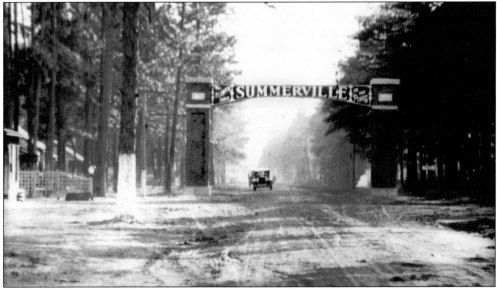

On the way into town in the mid-20th century, visitors were greeted with this overhead arch welcoming them to "Summerville: The Flower Town in the Pines." As they left, the other side of the sign reminded them of the town motto, "Let the Pine Be Sacred." The brick archway spanning the road was on the north side of town near today's intersection of North Main Street and Highway 78 (Fifth North Street). (MS.)

Four

BUILDING A COMMUNITY

By the 1830s, the railroad was running from Charleston through Summerville and a town was developing to serve the growing number of families settled in the area. "New Summerville" was laid out in 1832, establishing the downtown business district on Main Street near the railroad tracks. In 1835, postal service was established. The town incorporated in 1847, and a town hall was built around 1860. According to Charleston writer Elizabeth Anne Poyas, the 1860 census put the population at 1088 with 372 dwellings, nine stores, five boardinghouses, three churches, and two public buildings. The Civil War had slowed population growth a bit, but by the time Reconstruction and the 1800s ended, the historic district and downtown looked somewhat like it does today. Tourism and a number of grand inns fueled growth through the 1920s, but the Depression and the development of tourist destinations farther south caused it to taper off and kept the population under 4,000 residents until another boom in the 1970s. Since then, the Summerville area has ranked among the fastest-growing areas in the state. The U.S. Census in 2000 recorded 27,752 people; 11,087 housing units; and 2,939 businesses within Summerville's 15 square miles.

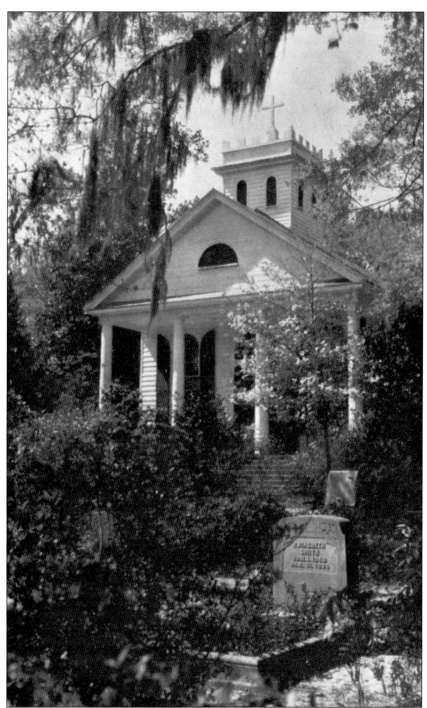

St. Paul's was established in 1828 as a summer location for members of the St. George Episcopal parish in Dorchester. The first sanctuary on West Carolina Avenue was built around 1830. This building was consecrated in 1858 and enlarged in 1878. Damage caused from the 1886 earthquake required the installation of support rods that can still be seen in the sanctuary. The adjacent cemetery contains many historic Summerville names. (JDH.)

Near St. Paul's entrance, the United Daughters of the Confederacy erected this monument, unveiled on Memorial Day 1915. The inscription reads, "'Their spirits were victorious their bodies only fainted and failed.' In memory of the Confederate Soldiers of 1861–1865 who with matchless courage, fought to maintain the principles of the constitution and perpetuate the government established by their fathers, and whose historic deeds crowned the South with deathless glory." (MAM.)

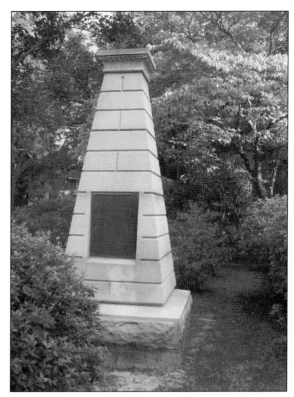

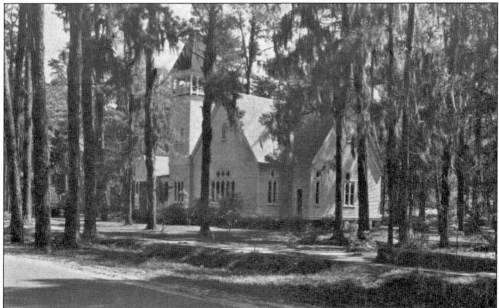

Summerville Presbyterian Church was built in 1895 to replace the 1831 chapel built for the summer use of the White Meeting House congregation from Dorchester. By 1859, the remains of that group were all enrolled here, and by 1882 their Meeting House ruins and adjacent cemetery belonged to Summerville Presbyterian. This Sumter Avenue building was renovated in 1980. The multipurpose center added in 1997 includes a stone threshold from the Meeting House. (JDH.)

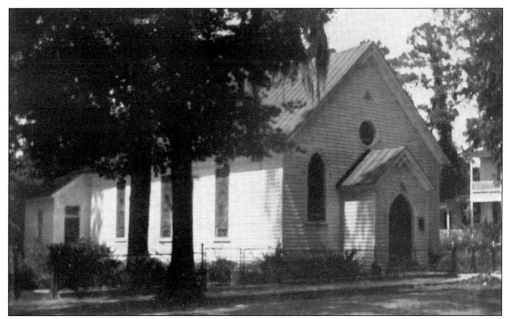

St. Luke's Lutheran Church was founded by nine families who originally met in the town's schoolhouse. The official birth date is August 25, 1892—the day the congregation accepted the church charter. This, their first church, was constructed in 1893. In 1987, the congregation dedicated a new sanctuary on Central Avenue. The original church remains in use as a chapel. (DB.)

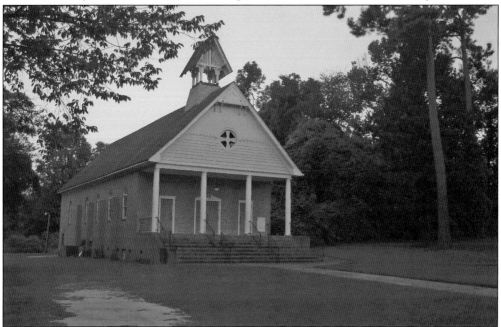

The Wesley United Methodist church building on Pressley Avenue was dedicated in 1884. Brick siding was added to the structure in 1984, but the exterior columns, ornate wooden belfry, and a stained-glass window (now inside) were all preserved in the update. The historically African American congregation was established in 1869 as St. Joseph's Church. It became Wesley Methodist Episcopal Church in 1877 and Wesley United Methodist in 1968. (JC.)

The March 16, 1839, Charleston diocesan newspaper contains the earliest mention of a Catholic congregation in Summerville. Though not an official mission, priests visiting from Charleston would celebrate Mass in the homes of local families. This original church on Sumter Avenue was built on land donated by the South Carolina and Georgia Railroad with the help of American soldiers assigned to Camp Marion, a temporary Spanish American War installation located near the Pine Forest Inn. According to *Catholic Diocese of Charleston: A History*, Rev. Daniel Berberick from St. Joseph Church in Charleston oversaw the construction; the cornerstone was set on May 15, 1898; and it was dedicated as The Church of St. John the Beloved. After 70 years of use and extensive growth in the congregation, a new church building was constructed and dedicated on April 13, 1969. Since then, the church has added a parish hall, a bell tower reminiscent of the original church, and a pipe organ. An extensive renovation of the sanctuary was completed in November 2007 and the original cornerstone from 1898 installed in the new church. (JDH.)

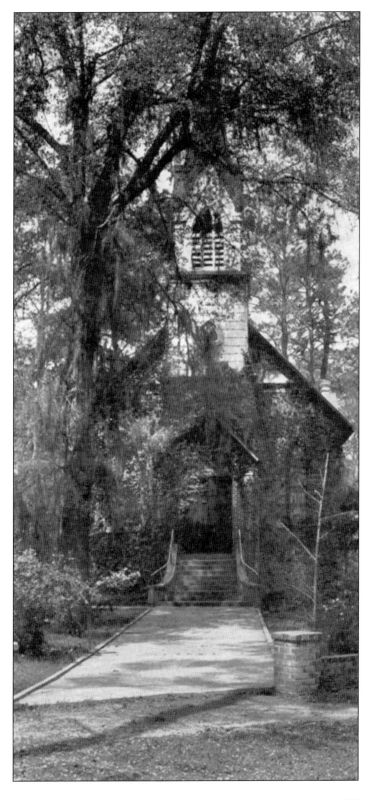

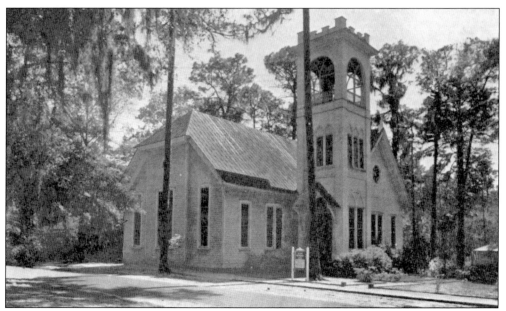

The wooden structure above is one of several used by the Bethany United Methodist congregation. According to the *Bethany United Methodist Church Commemorative 150th Anniversary Church Directory*, the church was founded by 17 members in 1857, grew to 143 members in the 1890s and, by its anniversary in 2007, occupied its fifth sanctuary and counted more than 3,000 in its congregation. This building appears to be the one built in 1883, improved around 1918, and razed in 1945. Bethany Methodist's first church building was located on West Richland Street and served until the 1880s when it was sold to a congregation that still uses that site today. Seen below, the 1947 Spell Chapel served until a still larger sanctuary was completed in 1980, which has become part of a campus that now includes a gym, numerous classrooms, a fellowship hall, and a child development center. (Both JDH.)

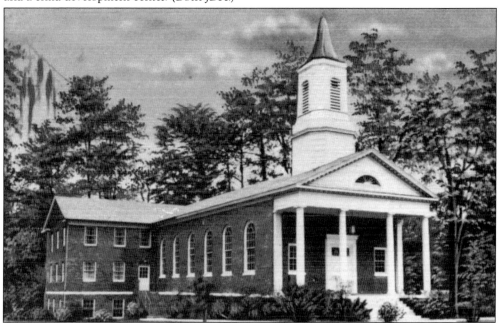

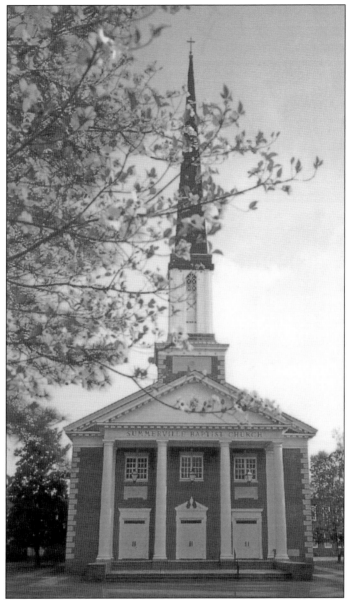

Around 1892, the Thornhill and Wilbur families began holding Sunday school and services in the Thornhill's home, where they were eventually joined by other Baptist families. Fourteen members signed the charter for Summerville Baptist Church on January 29, 1896. The fledging congregation purchased land on Second South Street and Pine Street from the South Carolina and Georgia Railroad. In 1897, Rev. Watson Scott Dorset became the church's first pastor, and the first building was dedicated on April 17, 1898. Membership in 1900 was 39; by 1935, it was 211. In 1948, the first services were held at a new larger church built on the corner of Carolina and Central Avenues. Growth continued through the second half of the century with the addition of a pastorium on Carolina Avenue, an education building, a Christian life center, a fellowship hall, and preschool classrooms. In 1971, the Carolina Avenue church was razed and construction began on a new building. The new sanctuary, shown here, was dedicated on May 27, 1973. The church celebrated its centennial in 1996 with a congregation of over 2,000 members. (SBC.)

The image in this postcard from the early 1900s is labeled "Sumter Avenue and Colored Baptist Church." It appears to be on the site of the fellowship hall that belongs to the current First Baptist Church of Summerville. The origins of this congregation date to before 1869 when a group of freed slaves led by Rev. A. Alston established a church on property donated by Judge Pressley. (SDM.)

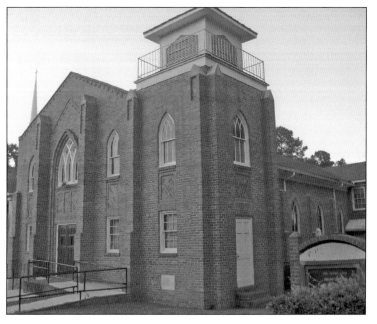

This impressive brick building with its cornerstone dated 1869 stands at the intersection of Sumter and Pressley Avenues across from St. John's Catholic Church. It once served as the sanctuary for First Missionary Baptist Church and is now the fellowship hall. Visible on the left side of the photograph is the steeple of the 500-seat sanctuary completed in 1992. A childcare facility is located behind this building. (JC.)

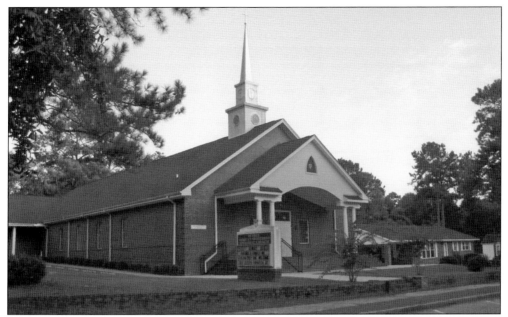

Summerville's Bethel African Methodist Episcopal Church dates back to tent services held on its present location on Main Street in the late-1800s. The congregation's first church was built on the site in 1884; it was destroyed by fire in 1932. Another church built here in 1941 burned in 2005. Members accepted the kind offer to meet at nearby Bethany Methodist Church until this new building was completed in 2007. (JC.)

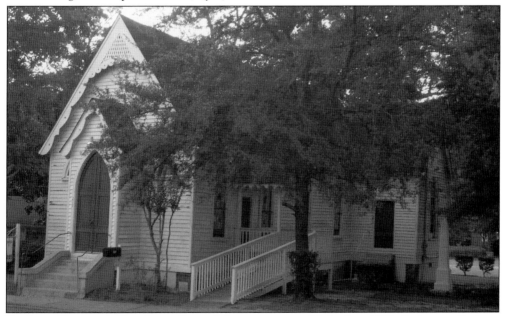

Epiphany Episcopal Church on Central Avenue was established in 1887. Catherine Springs, a talented and successful African American seamstress in the town, was instrumental in the founding and building of the church and the small school it supported. A monument to her located in the churchyard reads in part, "Erected by friends, who bear willing testimony that she did justly, loved mercy, and walked humbly with her God." (JC.)

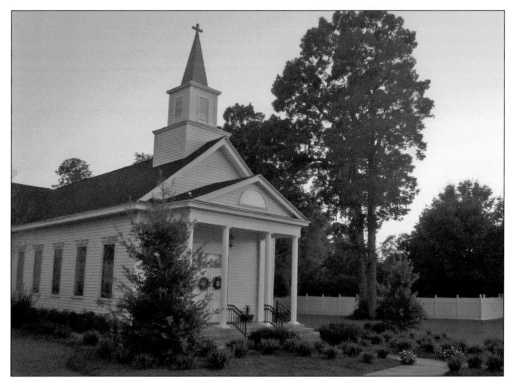

Stallsville United Methodist Church dates to around 1887 when a small village had grown in its strategic location on the route from Summerville to Dorchester and the Ashley River via Bacon's Bridge Road. Leaders received donations of land and money to build a church and, since then, it has served its own congregation and as an alternate site for the larger Bethany Methodist Church in Summerville when needed. (JC.)

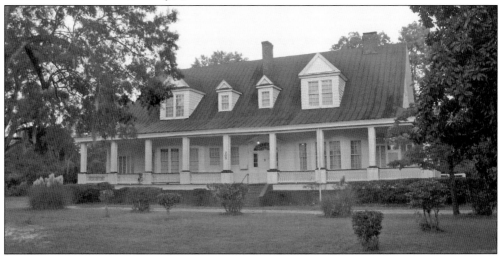

In 1924, when it initially moved from Charleston, the Cummins Memorial Theological Seminary for the Reformed Episcopal Church occupied a former hospital campus on North Main Street. After a 14-year hiatus, it returned to Summerville in 1980 to the former Pinewood School on South Main Street shown here. In 1981, the Bishop Pengelley Memorial Chapel was moved to the new site to complete the 3.1-acre campus. (JC.)

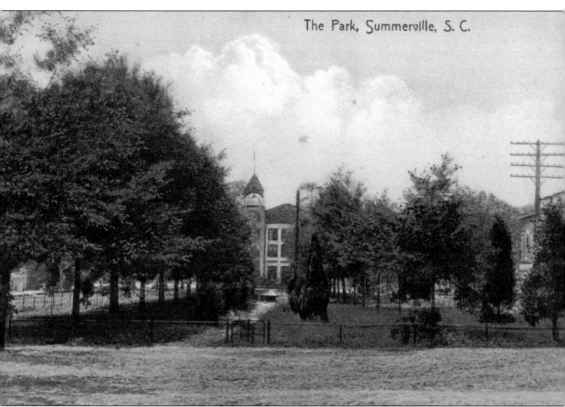

The Park, Summerville, S. C.

The park in downtown Summerville—named Hutchinson Park in honor of Edward L. Hutchinson, the first intendant (mayor) of Summerville—extends along Main Street from Doty Avenue by the railroad tracks south to Richardson Avenue where the town hall has been located since 1893. The surrounding fencing seen here kept roaming livestock from ruining the park; cattle gates were installed at all entry points. In the 1970s, concerned citizens saved the green space from becoming a parking lot for downtown merchants and restaurants. (DB.)

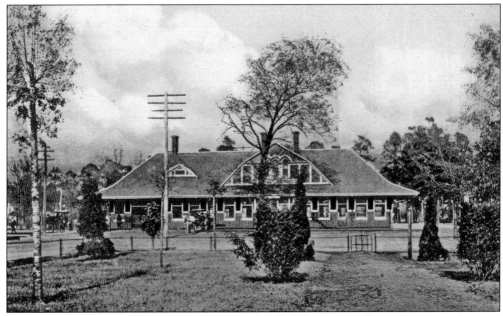

The Southern Railway Station sat at the opposite end of Hutchinson Square from town hall. As the official architect for the railroad company, Frank P. Milburn designed the depot around 1902. He was also the designer for Gibbes Museum of Art in Charleston and Summerville's Woodlands Inn. Out of use since passenger service was discontinued some years earlier, the station was torn down in the 1960s. (DB.)

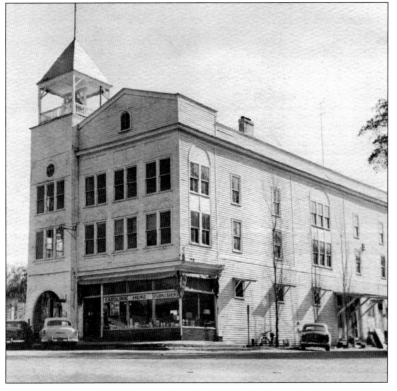

From 1893 to 1963, this building at the top of the square on Richardson Avenue served as the town hall—the third in the town's history. The first floor of the building had been home to the Tea Pot grocery store and then Carolina Home Furnishers. In the mid-1960s, it was declared unsafe and demolished. The new town hall was built on the same spot and opened in November 1969. (DD.)

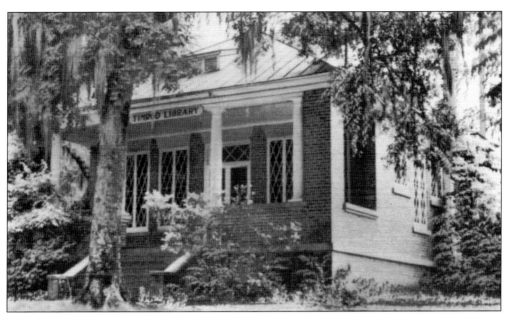

In 1897, a group of young Summerville women initiated the Chautauqua Reading Circle. While Chautauqua was an adult cultural education movement of the time, the Summerville group was mostly concerned with reading. Because books were expensive, the reading circle met weekly to exchange volumes. By 1908, the growing membership of 30 had changed their name to the Timrod Circle after Henry Timrod, a popular South Carolina poet considered Laureate of the Confederacy (right). The group became the Timrod Literary and Library Association after receiving a charter on April 23, 1908. Donations of land, brick, cement, labor, and money built the house on Central Avenue that has been the library's home since 1915. The Henry Timrod Library, with over 40,000 volumes in its collection, remains a private membership library supported by nominal dues, donations, and bequests. Listed on the National Register of Historic Places, it is the only library in downtown Summerville and is open to the public for browsing. (Above, JDH; right, TIM.)

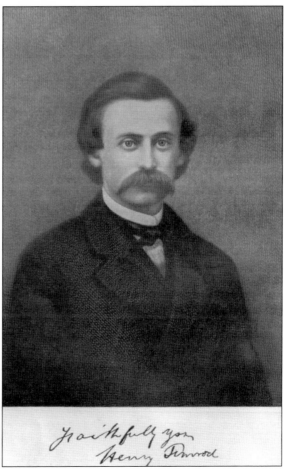

The original Clarence A. Dunning American Legion Post 21 hut was a log cabin set within the pines with a high lofted ceiling, large fireplace, dance floor, and pool tables. During World War II, the Legion Auxiliary hosted parties at the cabin for soldiers stationed nearby. The cabin burned down and a modest replacement was built in the same location on Sumter Avenue near Laurel Street. (DB.)

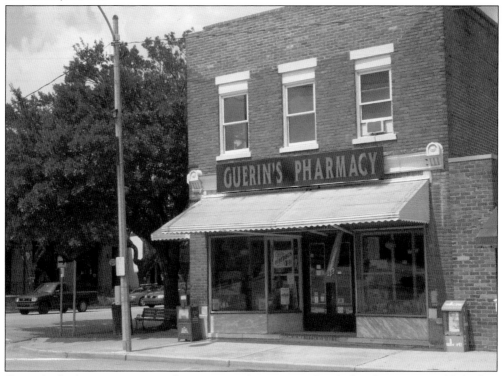

Guerin's, the longest continuously operating pharmacy in South Carolina, was established in 1871. The original wooden structure built by Dr. Henry C. Guerin at 140 South Main Street was bricked over in 1925. After his death, Guerin's son Dr. Joseph A. Guerin continued the business. It passed to longtime employee Dr. Herbert F. Dunning, then to his nephew Charles H. Dunning. Charles's daughter Barbara A. Dunning is now the pharmacist in charge. Guerin's Pharmacy still has its old-fashioned soda counter serving milkshakes, floats, and hot dogs. (JC.)

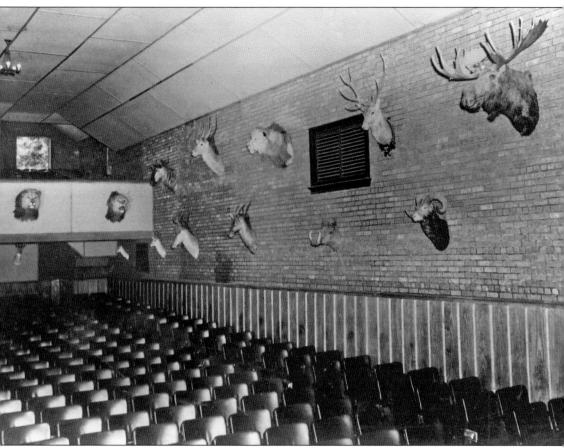

The James F. Dean Community Theater at 133 South Main Street was originally the Summerville Theater, which locals called "the show." Carolina Films opened the 418-seat movie theater around 1935. Part-owners Sidney and Gertrude Sanford Legendre elaborately decorated the theater's interior walls with the trophies from their safari trips to Africa—most of them hers—shown in this photograph. The theater flourished as a movie house until the early 1960s. Older residents may remember attending the Westerns, historic epics, and science fiction films of the 1950s at the theater and going out afterwards for refreshments at one of the pharmacies on the square or to the drive-in (if they had a car). In 1976, local residents formed a theater group called the Flowertown Players. Their restoration of the old movie house included updating the facade and installing cushioned seats. In December 1976, they opened their first show in the facility: *Six Rms Riv Vu.* (FP.)

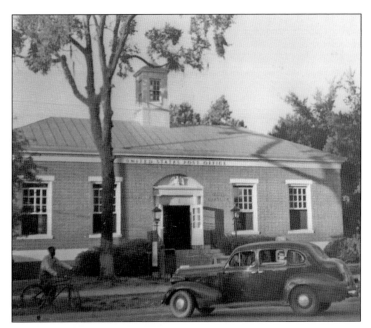

The Summerville Post Office has had many homes since it opened in 1835. After being located in a variety of buildings, including a custom-built post office on North Main Street, it settled into this one at 135 West Richardson Avenue in 1938. Today this structure houses the Summerville Commissioners of Public Works. In 1983, the U.S. Post Office moved to a larger facility on North Gum Street. A second Summerville branch is located in Oakbrook. (SDM.)

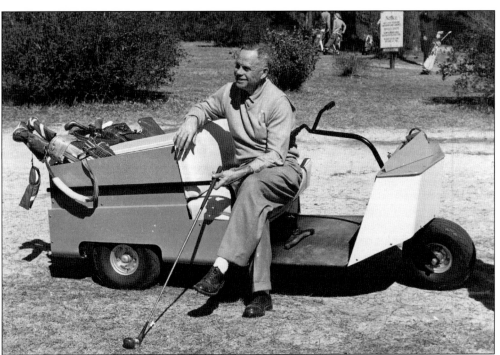

George "Chick" Miler established the George Miler Golf Club at 400 Country Club Boulevard off South Main Street in 1925. Now the Summerville Country Club, the semiprivate 18-hole regulation course is host each year to the Chick Miler Invitational tournament. Held on Memorial Day weekend, the competition draws over 200 amateur golfers to Summerville from all over the South. This photograph was taken around 1945. (McK.)

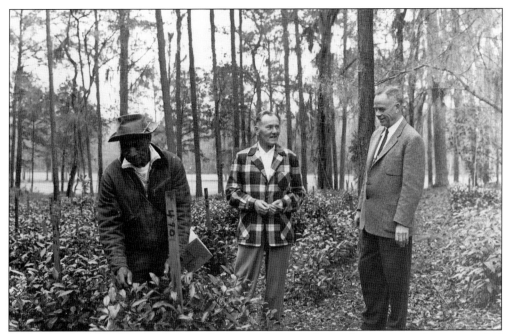

Miler (right) and two unidentified men look over plants on the tea farm property that surrounded the George Miler Golf Club around 1950. In addition to his interest in golf, Miler is credited with helping to start the Summerville High School football team. He was a strong supporter of SHS athletics; the school's golf team still calls Miler's golf course home. (McK.)

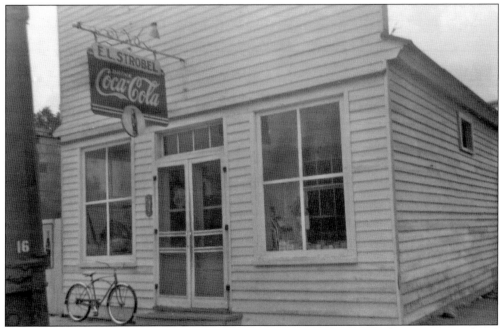

Strobel's was a grocery store next to the Coca-Cola bottling plant on Cedar Street owned and operated by E. L. Strobel. Shown here in 1965, the old-fashioned grocery included large wooden barrels of staples like flour and corn meal. The wooden counters were polished to a shine. An old Regulator wall clock behind the register ticked away the minutes. (EMS.)

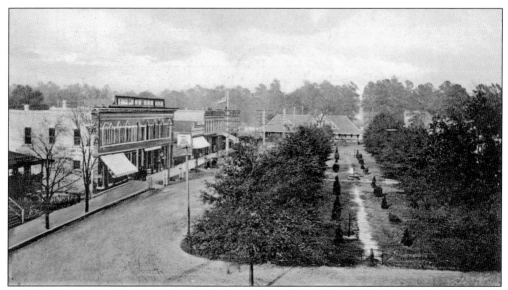

This shot of Main Street looking north was taken around 1908. In 1965, B. E. Anderson's CPA firm was on the second floor of the building on the left. One night, while working late, Anderson felt a presence behind him. He turned and saw a shadowy, dark man watching him. After a few seconds, the figure disappeared. Anderson said he felt like he was being warned. CPA Pete Chellis reported a similar incident seven years later. (DB.)

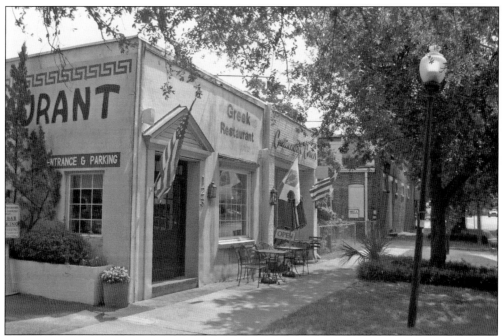

In 1973, the Continental Corner Greek Restaurant opened at West Richardson Street offering Mediterranean gifts and imported food products. Summerville's Ernest Yatrelis and his friend Thomas Mavrikes from Cleveland began serving sandwiches and salads in September 1974. Since then, the restaurant and its menu have expanded to include dinner and Sunday brunch. After more than 35 years, "The Corner" is still a popular downtown eatery. (JC.)

Alston Graded School opened in 1910 on North Cedar Street in a two-story wood frame schoolhouse and operated there until moving to Bryan Street in 1953. One of the first African American schools founded in Dorchester County, the school included grades 1–11 until 1949 and 1–12 thereafter. The new one-story brick school on Bryan Street closed in 1970 after the desegregation of county schools. Alston Middle School is now on the Bryan Street site. (JC.)

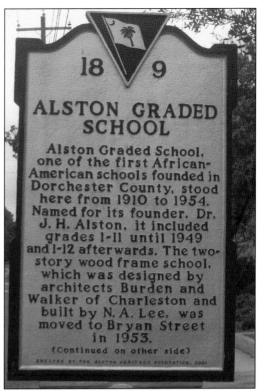

This building (shown around 1938) at 815 South Main Street was home to Summerville High School (SHS) beginning in 1924. In 1969, the high school moved to its present campus on Boone Hill Road, which has since expanded several times. Rollings Middle School of the Arts opened in this location in 1996. The school is named for R. H. Rollings, a beloved longtime history teacher at Summerville High School. (HAT.)

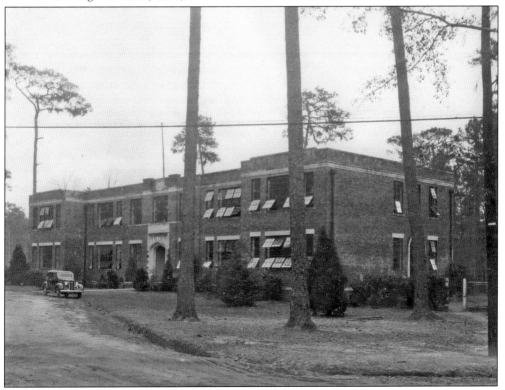

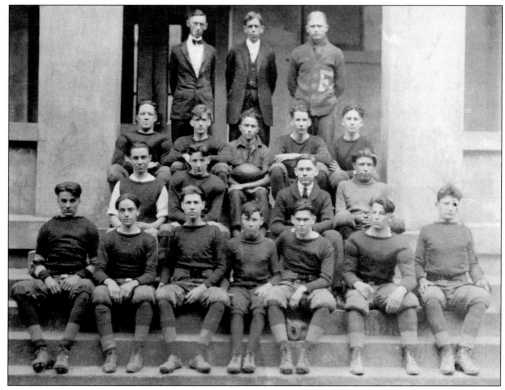

SHS fielded its first competitive football team in 1922–1923, and the team had a successful 5–1–1 season. From left to right, the c. 1923 team portrait seen here includes (first row) Webster, Priebe, Mellechamp, Sweet, Vaughn, Riggs, and Salisbury; (second row) Flichmen, Waring, Moorer, and Salisbury; (third row) Igoe, Walker, Limehouse, Rhame, and Pfaehler; (fourth row) Coach Jennings Limehouse, Superintendent James H. Spann, and Coach Nelson—also the team's manager. (McK.)

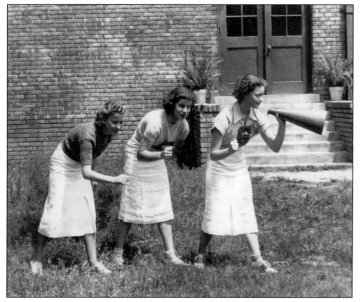

The cheerleaders' uniforms in 1938 were a little different than those today, but the girls' purpose was still to direct the crowd with rousing cheers in support of their team. From left to right, the Summerville High School cheerleaders for 1938 were Lovic Waring, Frances Vincent, and Caroline Smith, as well as Eugenia Maass (not pictured). The football team ended the 1938 season with a 6–3 record. (HAT.)

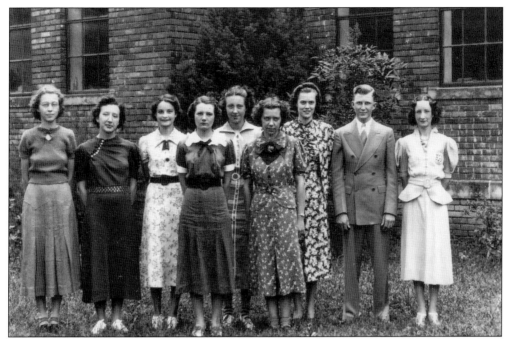

In 1938, business coursework at SHS was called "outside commercial class." The students seen here from left to right are Dorothy Knight, Carrie Bell Swicegood, Elizabeth Nix, Vivian Gunter, Helen Cabe, Ida Belle Welch, Junelle Bolen, Berlin G. Myers, and Margaret Vaughn. At least one graduate became a successful businessperson and community leader: Berlin G. Myers owns a lumber company and has been mayor of Summerville since 1972. (HAT.)

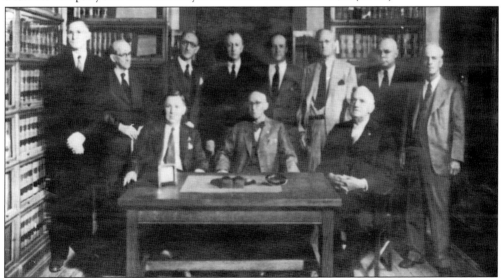

The British Crown established the Dorchester Free School Board in 1724. It moved to Summerville in 1817. The board converted to a college scholarship program in 1912 and still operates today; descendants of original board members fill open positions. Seen here is the board from around 1940. From left to right are (seated) Saussure Debon, John Gadsden, and Edward Hutchinson; (standing) Frank Smith, William Gadsden, Henry Burden, Joseph Guerin, Jennings Foster, Legaré Walker, William Boyle, and Braly Miler. (SJB.)

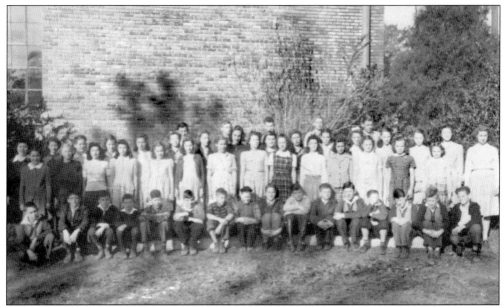

If the students in this 1943 SHS class look a bit young to be in high school, that is because they are. Students originally started at Summerville High School in the seventh grade and graduated after completing their 11th-grade year. Betty Jane Moorer was SHS seventh-grade class president in 1943; Russell Murray served as vice president. Dorothy Elliott and Jonnie Sue Brown were the seventh-grade teachers. (McL.)

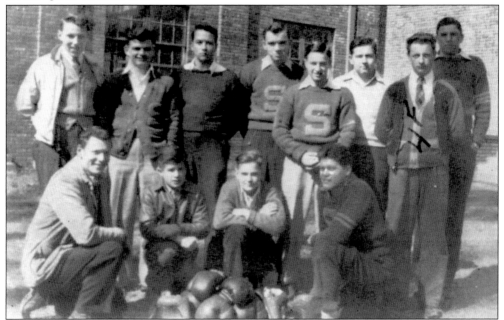

Eric Anderson (standing, fourth from right) was captain of the 1943 SHS boxing team; football team cocaptain; a basketball player; member of the newspaper staff, block-letter club, and dance club; yearbook art editor; and senior class president. After high school, Anderson enlisted, serving in World War II, the Korean War, and Vietnam. Retired in 1979 as a sergeant major, he became a military magnet school instructor. (McL.)

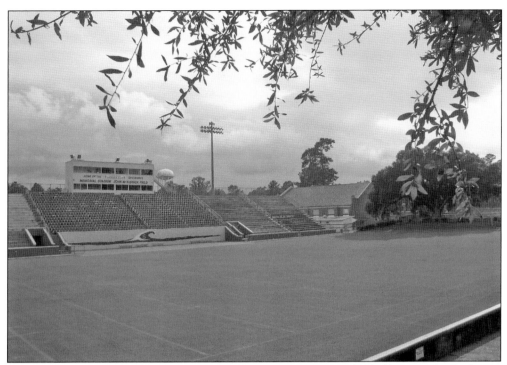

Summerville Memorial Stadium is home to the SHS Green Wave football team. The Exchange Club erected the stadium in 1949 as a permanent tribute to the eight men from the town who died serving in World War II, replacing the minutemen honor roll billboard of those serving in the war that had been located in the town square. Started with the names of 150 residents in 1942, the billboard had extended to include over 400 names by September 1944. (JC.)

The 1949 SHS senior class officers were, from left to right, Le Van Rhame, president; Wayne Umphlett, treasurer; Grace Norton, secretary; and Tom Thornhill, vice president. The yearbook recorded their edict for improving Summerville's schools: "Much has been accomplished, even more has been left undone . . . We are confident that there is courage, devotion, talent, and sufficient material wealth for a successful 'Operation Progress.'" (SJB.)

In addition to formal classes, in 1949, SHS students could participate in student council, the *Green Wave* yearbook, the *Pine Log* newspaper, band, art, music, the National Honor Society, Future Farmers of America, Junior Homemakers of America, the block-letter club, and driving class. History teacher R. H. Rollings (left) taught the drivers' education course for many years. (SJB.)

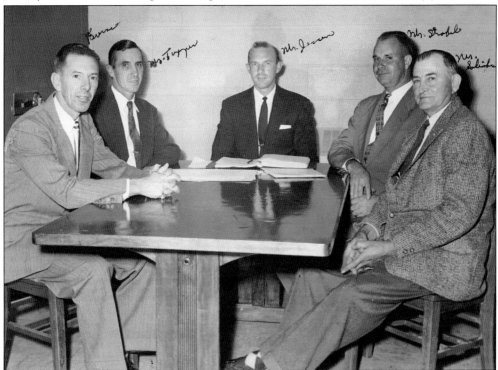

The members of the 1952 Dorchester School District Two Board of Trustees were, from left to right, Burns Meyer, George Tupper, Herbert Jessen Jr., John Lloyd Strobel, and Evans Salisbury. Among what were surely many accomplishments that year, they hired John McKissick as the football and basketball coach for Summerville High School. (McK.)

This photograph shows John McKissick in 1952, the year he began coaching the Green Wave football team. The previous coach, Harvey Kirkland, had been with the SHS team from 1946 to 1951 and had brought home the school's first two state championships. McKissick would better his record—and everyone else's. In 1993, he became the winningest high school football coach in history when he broke the record of 405 wins held by Gordon Wood of Texas since 1985. (McK.)

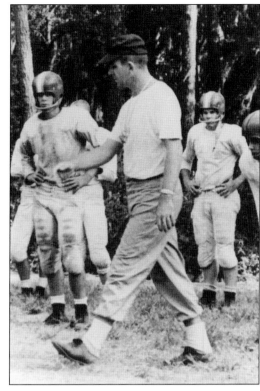

For many years, Summerville High School dances were held in Ambler Hall at St. Paul's Church. Constructed in 1924, it was later named for Rev. Francis W. Ambler, who served 32 years as rector. The facility was one of the only large meeting spaces in town and is still used extensively, having been renovated in 1987. In 1952, McKissick and his wife Joan were chaperones for this high school dance. (McK.)

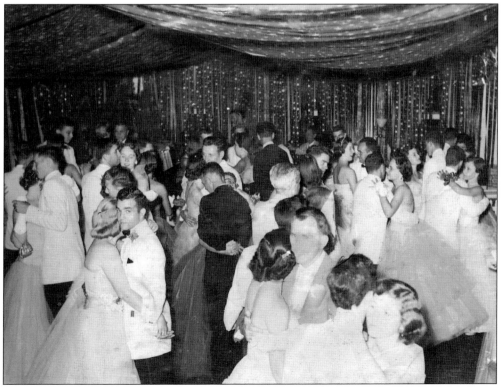

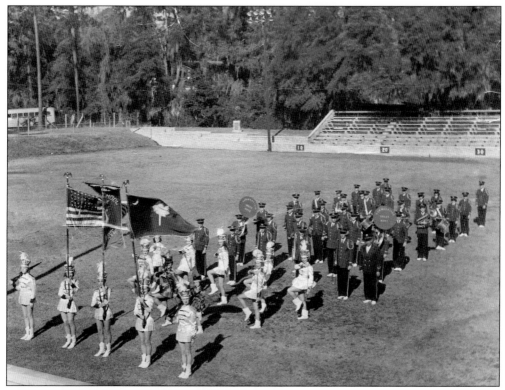

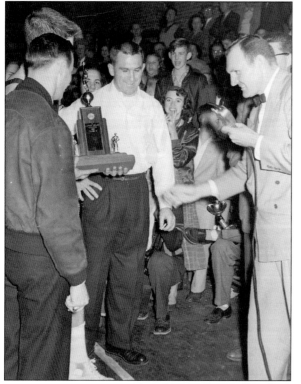

Frank deParle was SHS's first band director. He came to the school after World War II when he retired from the navy, where he was a bandmaster. Around 1952, when this photograph was taken, the band had acquired proper uniforms and learned to march. They had been teased by onlookers for riding on a truck during one of their first parades. (McK.).

In 1955, Coach McKissick (center) led the SHS basketball team to the South Carolina Lower State Boys' Basketball Championship. However, football is where he excelled. Along with winning 10 state football championships, the coach has led his teams to victory in more games than any coach, on any level, in the history of football—with 586 wins as of the 2010 season. (McK.)

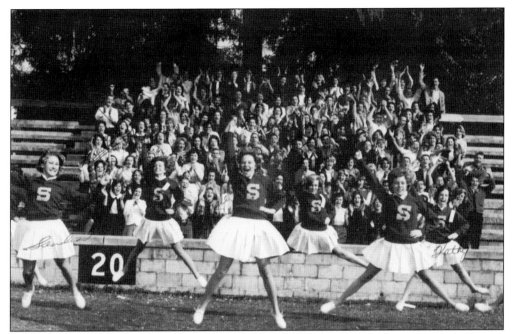

Summerville High School's first pep club was established in 1964. By then, the football team had won four state championships (1948, 1949, 1955, and 1956). Dues for the pep club were 50¢. The club officers were Judy Naylor, Sandy Cates, Catherine Tupper, Sissue Boyle, and Hazel Spain. (SJB.)

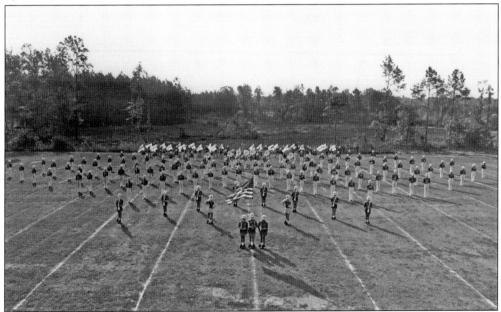

When Gus Moody took over as band director in 1960, there were 21 students in the SHS band, which included grades 7–12. The program grew extensively until it had 175 members in 1986 when Moody retired. In addition to the marching band, there was a dance band, a concert band, and over 700 students were taking band classes. This photograph was taken on the practice field around 1970. (GM.)

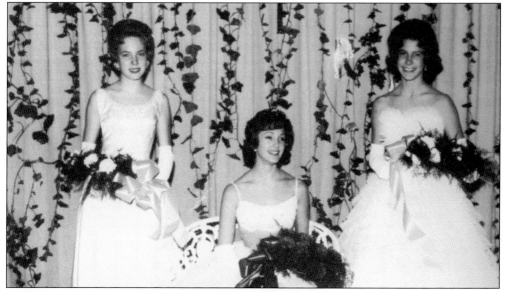

Virginia "Cookie" House (center) was crowned Miss Summerville High School in 1964. She posed for photographs with the runners-up, from left to right, Sherry Douglas (second runner-up) and Helen Moore (first runner-up.) Other winners that year were Cynthia Ann Minard as Miss Green Wave, Ruth "Coo" Prettyman as Homecoming Queen, and Mary Foster as May Queen. (SJB.)

In 1966, Summerville High School went international. Rolf Thiemann of Bavaria, Germany, arrived as the school's first foreign exchange student. He excelled in academics and athletics as a member of the football, track, and basketball teams. Thiemann also made the world seem a little smaller as he made many friends in Summerville. (SJB.)

Five

LIVING HERE

In the South Carolina Lowcountry Gullah dialect, people born to families that have lived here for generations are known as *ben-yahs*, because they have "been here." Newcomers (those whose families have arrived in the last 100 years or so) are known as *com-yahs*, because they have just "come here." Since its earliest days, Summerville has been a place people have come to—once a haven from the Lowcountry heat and fever-bearing mosquitoes, later a respite for those suffering from respiratory ailments, and finally a place where those from colder states could avoid winter. Some stayed to become residents while others only spent the season, the month, the week, or the day. Whatever the length of their visit, tourists to the area expected—and were provided with—recreation and entertainment. Residents have been able to take advantage of these same opportunities, but living in Summerville is different from visiting. With a population of less than 7,000 until the 1980s, Summerville was a small town for many years, the kind of town where everybody knew everybody—and might be in some way related. Even today, with over 30,000 residents, much of that feeling remains.

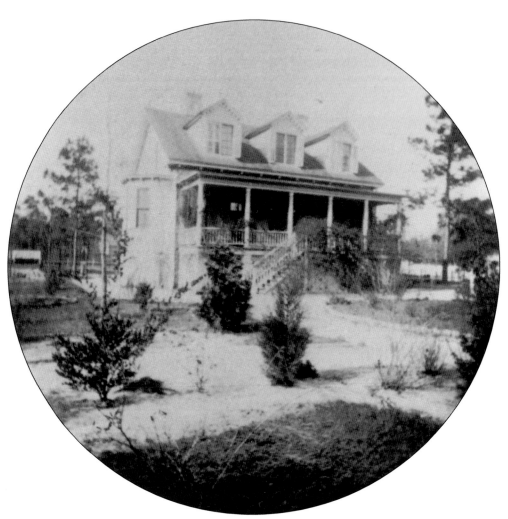

Linwood, located at 200 South Palmetto Street, was built in 1883 by William Hastie and his wife, Julia Drayton. She was the daughter of Rev. John Grimke Drayton, who inherited Magnolia Plantation from his grandfather. Drayton lived with the Hasties and their children Marie Clinton and C. Norwood at Linwood for a time. He died there in 1891, leaving the plantation to his daughter. In 1901, the family moved to Magnolia Plantation and sold the Summerville house. The two-story clapboard Victorian includes a center-hall plan with heart-of-pine floors, triple-sash and bay windows, multiple fireplaces, and a basement kitchen. It remained a single-family home for most of the 20th century. Peter and Linda Shelbourne purchased the property in 1979 as their family home. After restoration, upgrades, and significant landscaping, they opened Linwood Bed and Breakfast in 1994. While keeping the historic ambiance with original features like a claw-foot tub and working fireplaces, they added modern amenities such as private baths and an in-ground pool. (PLS.)

Dressed for business, William Hastie (right) waits for his carriage to be brought around. "Simmonds" (below) worked for the family and may have driven for Hastie. The original property included a carriage house and stables that were sold by new owners in the early 1900s. The Hasties' home was located on two acres of enviable property. For transportation into Charleston, Hastie could walk to the train station just one block away. The steam locomotive carried many Summerville men to their jobs each morning and home again in the evening. The men passed the time reading the newspaper or playing cards. There are rumors that gambling occurred, and some men lost their paychecks before arriving home. Others arrived with winnings in their pockets. (Both PLS.)

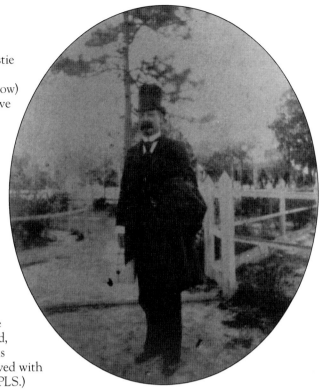

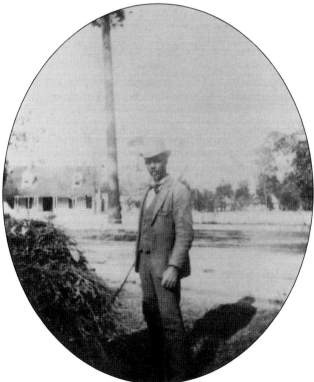

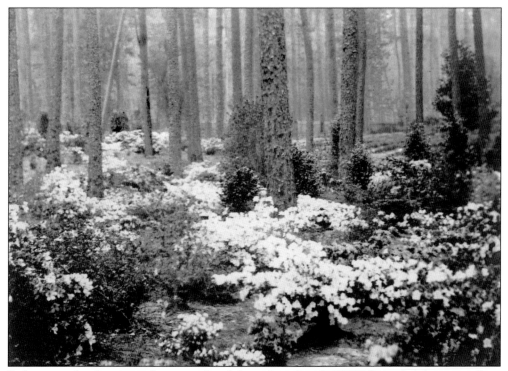

Pathways under the pines often meandered through multicolored gardens of azaleas, camellias, dogwoods, and many other indigenous plants. One such path led through the Azalea Garden at Pinehurst Tea Plantation, seen here around 1910. (DB.)

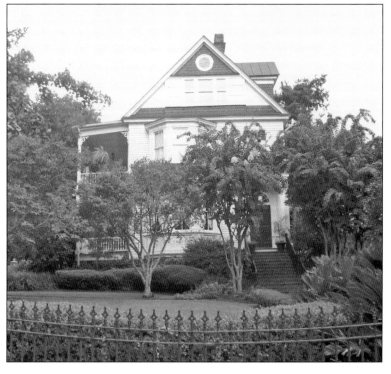

A. J. Baird, who constructed the Pine Forest Inn, built the home at 208 Sumter Avenue in 1891 for Samuel Lord, a Charleston attorney. Florence Nightingale Graham, also known as Elizabeth Arden, the international cosmetic firm founder, purchased the home in 1938 as a winter residence and owned it until 1954. It is still referred to as the Elizabeth Arden House. (JC.)

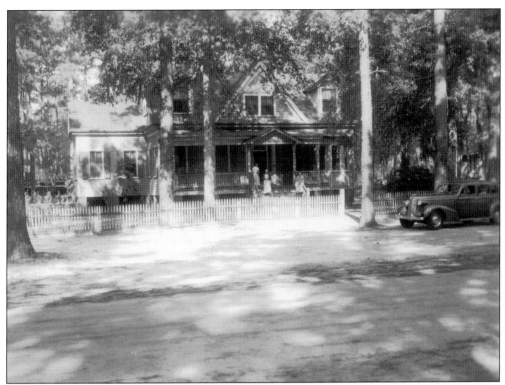

John F. Cordes and his wife, Caroline Ducker Cordes, moved to Summerville in 1904 with their three children: Helen, Albert, and Maud Rosina. The family lived in this house at North Black Jack Street and West First North Street until 1967. In the 1940s, Black Jack Street's name was changed to Cedar Street. The SCE&G building is now located on North Cedar Street where the home once stood. (MLP.)

Maud Rosina Cordes was 11 when she dressed up for this portrait in 1915. She moved to Summerville when she was just six weeks old. The Duckers, her mother's family, had lived there in the 1800s. The Cordes family lived just across the street from the Duckers' former property. Family history indicates that her grandparents, Cushon Ducker and Rosina Solman, were married on December 20, 1860—the night South Carolina seceded from the Union. (MLP.)

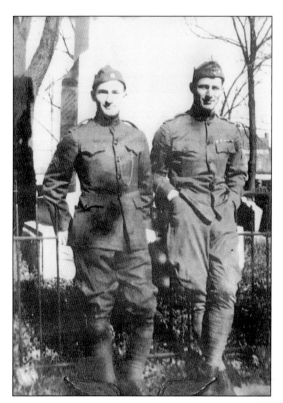

Bradford Eric Anderson (left) and his brother Robert Eldon Anderson (right) both served in World War I during the U.S. involvement from April 1917 to November 1918. The two doughboys were stationed in France. (REA.)

B. E. Anderson kept a diary of his experiences during the war. Throughout the remainder of his life, Anderson was very active in supporting the U.S. military. During World War II, he created a newsletter for the Sons of the American Legion in Summerville. With the help of other legionnaires, he wrote about the town's service members and printed and distributed the newsletter. Local news and information about other soldiers kept those serving abroad linked with their hometown. The newsletter grew to a circulation of over 400, and several reunions in foreign lands were made possible by Anderson's efforts. (REA.)

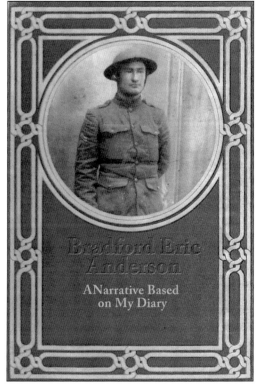

Bradford Eric Anderson

A Narrative Based on My Diary

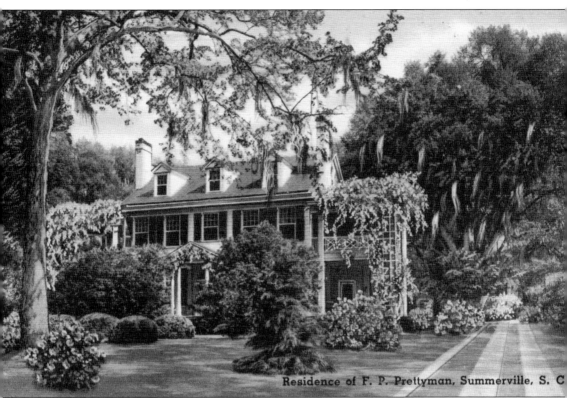

Residence of F. P. Prettyman, Summerville, S. C

A popular postcard of Summerville from the 1920s showed the F. P. Prettyman residence. Frank P. Prettyman was the secretary-treasurer of his family's lumber and milling company. He managed the manufacture, sale, and shipment of the mill's products. His brother Cannon F. Prettyman managed the land, logging, and railroad operation. Their father had established J. F. Prettyman and Sons in Summerville in 1902 after over 40 years' experience in the lumber industry in Pennsylvania, North Carolina, and in the town of Marion, South Carolina. Prettyman built his own logging railroad north of town to ensure a steady supply of timber for the sawmill operation. F. P. Prettyman lived in this home with his wife Isabel Cross of Marion and their two children, Virginia Fleming and Howard Cross. (DB.)

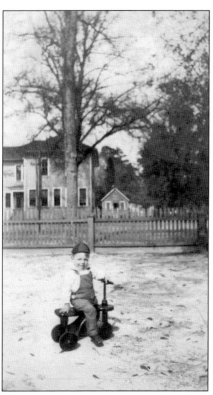

In 1921, two-year-old Herbert Braid enjoyed riding his tricycle in the yard of his grandmother's home on North Cedar Street. The Alston School can be seen in the background across the street. (MLP.)

The Bolen House at 302 Sumter Avenue was built in 1896 by Dr. William H. Prioleau when he moved to Summerville for the healthy climate. The Victorian-style residence included 10-foot ceilings, double fireplaces, and glass transoms over all interior doors. In 1898, the Prioleaus moved to Asheville, North Carolina, and sold the home to F. Julian Carroll. It passed through five more owners before David D. Bolen purchased it in 1925. It remains in the Bolen family. (SBG.)

Bolen moved to Summerville to manage the Coca-Cola bottling company located on Black Jack Street (now Cedar Street). Bolen and his wife, Lottie Lee Fogle, had seven daughters, one for each of the seven gables in their Sumter Avenue home—although a close count indicates there may be eight, gables that is. The first six girls were named Virginia, Lottie Christine, Daisy Irene, Mildred Clarissa, Martha Dora, and Elizabeth Junelle. Bolen was eager to have a son, but on the birth of his seventh daughter, his wife told him he had missed his chance for a boy's name. Bolen responded by naming their last daughter David Dorothy Bolen—she was known as "Dot." The seven grown daughters photographed below with their mother around 1950 are, from left to right, Virginia, Junelle, Dora, Dot, Christine, Irene, and Mildred. (Both SBG.)

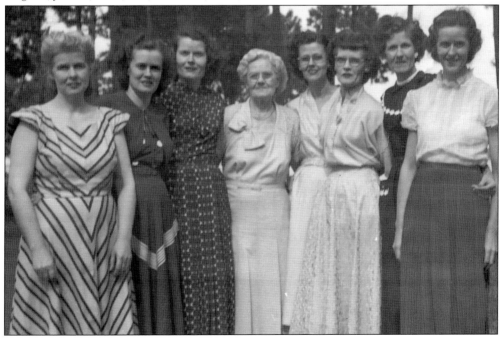

John Hayden Godfrey Jr. was a happy, healthy toddler in 1933. Godfrey made medical history as a teenager when surgeons removed a supra adrenal gland tumor from his abdomen. Said to be the size of a football, it was the largest on record at the time. In 1949, the seven-hour operation was more perilous due to Godfrey's rare blood type: AB, Rh positive. Donors from as far away as Columbia, South Carolina, and Atlanta, Georgia, answered the call. (SBG.)

Margaret Luke (left) and her best friend Patsy Dunning dressed up as flowers for their first grade school play in May 1938. Margaret was a sweet pea. Patsy was a daisy or maybe a buttercup. (MLP.)

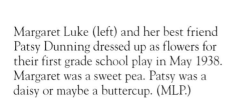

Benjamin David Godfrey remembers the azalea bushes that grew on either side of his Godfrey grandparents' front steps on Central Street when he was a child. They were so tall that they almost reached the roof of the house. In 1938, toddler Godfrey held onto an azalea branch to steady himself as his photograph was taken. (SBG.)

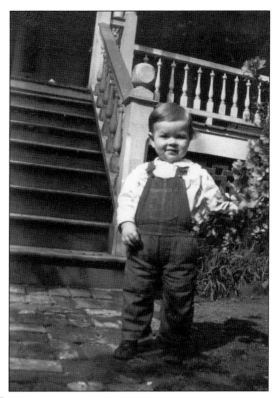

David. D. Bolen and his grandson Benjamin David Godfrey posed behind the Bolen home on Sumter Avenue for this photograph in 1939. Godfrey's mother, Christine Bolen Godfrey, was one of Bolen's seven daughters. (SBG.)

The Godfreys' home, with its elaborate azaleas, is located at 404 Central Avenue. Benjamin H. Godfrey purchased the home in 1937 and the family lived there until 1959. It originally had a central hall with two rooms on each side, front and back porches, and a separate kitchen in the yard. The long front stairs are due to the home's height off the ground; like many of the era, it was built on brick columns. An early 1900s owner, William Lanneau, added rounded porches with shingled cupola roofs on either side of the front porch. (SBG.)

A young woman might receive an invitation to enter the Miss Summerville contest. The crowned queen could then go on to compete at other contests like the Azalea Festival Queen competition in Charleston. One of the seven Bolen daughters posed in her formal gown at her parents' home before leaving for the contest around 1938. (SBG.)

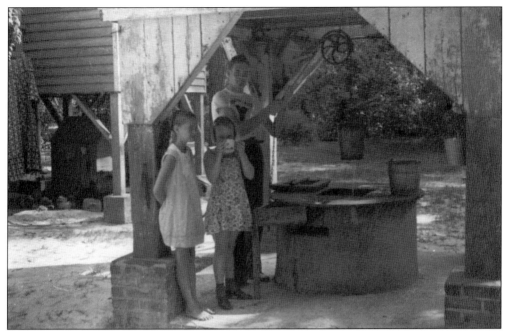

In 1940, June Madson (left), Margaret Luke—granddaughter of Caroline Ducker Cordes—and Dick Carroll could still enjoy a refreshing cup of water from the working well in the back of the Cordes's house on Cedar Street. There had been plumbing in the home for several years by then, but the children liked to drink from the well. (MLP.)

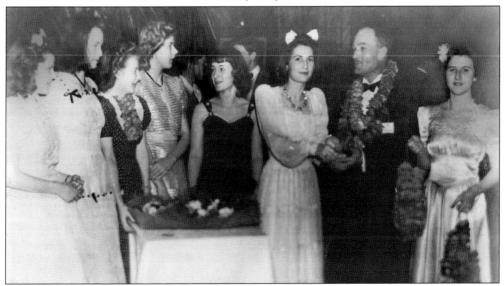

In April 1941, the Azalea Festival Ball was held at the Pine Forest Inn. Some of the young women were asked to sell lei made from azalea blossoms to the attendees. From left to right, May Aldret, Elsbeth Wattles, Margaret Hutchinson, Magie Peters, Annette Jones, Helen Anderson, Hugh Hamilton, and Margaret Finucan posed as Anderson presented Hamilton, the town treasurer, with the proceeds. Anderson recalls that the Saturday night ball was formal; everyone dressed up and had dates. Friday night was a more casual sock hop at the Summerville High School gym featuring dancing to big band music. (HAT.)

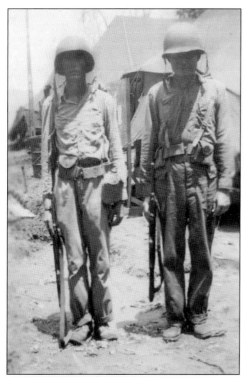

December 1941 brought Pearl Harbor and America's entry into World War II. Many Summerville men served in the armed forces. Marion Hall Waring (above, left) was stationed in Luzon, Philippines, with the Navy Seabees. Waring married Helen Anderson before shipping out. They were one of the few couples with enough time for a small wedding ceremony. Helen even had a wedding dress, and the Warings honeymooned in New York City. Waring left six weeks later, and the couple did not see each other for two years. Like many couples, however, they wrote letters daily. Marion's brother Francis Malbone Waring (below) joined the U.S. Army Air Corps. He was an administrative officer who rose to lieutenant colonel before retiring in 1962. The Warings are descendants of Dr. John Ball Waring, who served in the Confederate army in Charleston and Virginia. (Both HAT.)

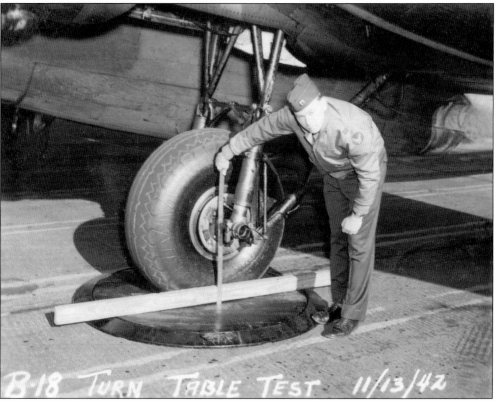

B-18 TURN TABLE TEST 11/13/42

Summerville resident Capt. William "Bill" Augustus McIntosh, seen on the left in this photograph, spent World War II in the Pacific in foreign places like Leyte and Cebu in the Philippines. In 1945, he was stationed in Hokodate, Japan. (AM.)

That same year, Gladys Gibbs Whitehurst drew this little sketch of her daughter Bethel "Beth" Griggs Whitehurst (left). Beth sent it to her future husband, McIntosh, who carried the drawing with him through the remainder of his tour. After he came home, he returned the sketch to Whitehurst, who put it in her scrapbook. Like many others, she kept scrapbooks with newspaper clippings of war stories, as well as letters and photographs sent to her by her fiancé serving overseas. The McIntoshes were married in January 1946 and settled in Summerville. (AM.)

Ralph Donald Luke, pictured in 1940, was in his early twenties when he first moved to Summerville from Pennsylvania during World War I. Because of his poor eyesight, Luke could not enlist, so he served his country as an electrician at the Charleston Navy Yard, working there until his retirement in 1957. Though the Luke name had long been prominent in Summerville, Ralph would jokingly explain that he was not part of that family, saying, "We're the poor Lukes." (MLP.)

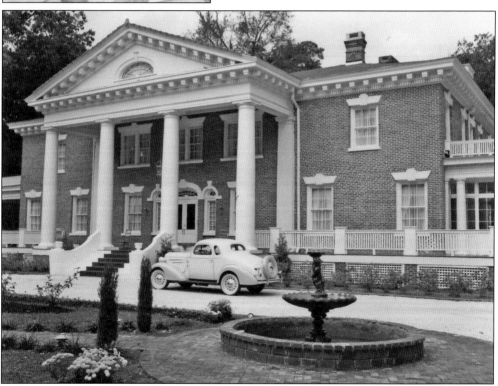

On December 25, 1941, Alain Campbell White held a Christmas dinner party for soldiers in the area. It was the first of many parties that White held at his home for servicemen stationed around Summerville. In 1906, Robert W. Parsons, a Pennsylvania railroad baron, built the house as a winter home for his family; they called it Woodlands. Frank P. Milburn, architect for the South Carolina State House and Gibbes Museum of Art in Charleston, designed the house. (WI.)

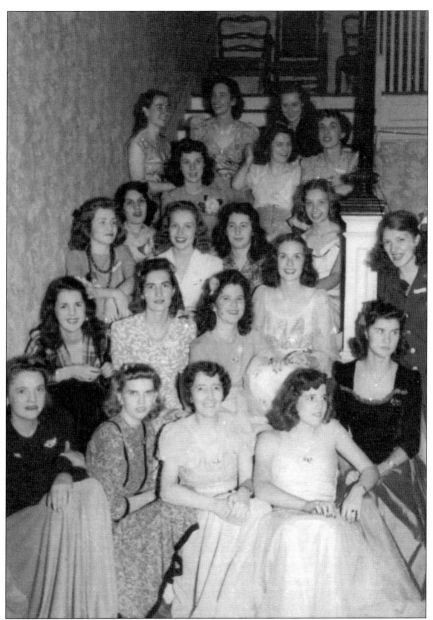

White invited young women from Summerville, Charleston, and Columbia to attend his parties and spend time with the soldiers. Sometimes—especially in the beginning—he gave them gifts for attending. One gift was a sterling silver pin; another was a sterling silver bracelet. The soldiers were given cartons of Lucky Strike cigarettes. The girls gathered on the stairs for this photograph—some wearing their pins. From left to right, the girls are (first row) unidentified, Carol Finucan, unidentified chaperone, and unidentified; (second row) unidentified, Helen Anderson, Margaret Finucan, and unidentified; (third row) Carlotta Jenkins, Jessie Stoney, Juliet Wattles, Betty Jo Anderson, Elsbeth Wattles, Florence Wattles, and ? Sosnowski (standing); (fourth row) Sue Smith, Dottie Thompson, and Margaret Walker; (fifth row) Eleanor Walker, ? LeBruce, and Elisabeth Seabrook. The four unidentified girls came from Columbia with a friend of White's as their chaperone. (HAT.)

During the winter months, the parties at Woodlands were elegant Saturday evening affairs. When the weather turned nice, they moved to Sunday afternoon and to the front lawn. Tables were set under the shade trees for refreshments and conversation. The guests would also play badminton, croquet, and parlor games. White put loudspeakers on the porch and played records by Glenn Miller, Tommy Dorsey, and other big bands for everyone outside to enjoy. (HAT.)

White grew up in Danbury, Connecticut, as a member of a prominent family. He and his sister Mary inherited land, money, and a love for undeveloped forest from their father and aunt. As founders of the White Memorial Foundation, they contributed over 6,000 acres to the State of Connecticut for parks. When they moved to Summerville in 1932 due to Mary's failing health, they continued their philanthropic endeavors. (HAT.)

In 1943, while her older brother William Augustus Boyle Jr. was away serving in the Army Air Force, Mary Boyle dressed in a Women's Army Corps (WAC) uniform to have her photograph taken. Over 150,000 American women served in the Women's Army Corps during World War II. Other than nurses, they were the first women to serve within the ranks of the U.S. Army. (SJB.)

Like many in 1943, William Augustus Boyle Jr.'s family celebrated Christmas without him. For years to come, the family tradition was to gather for the holidays at his parents' home on Carolina Avenue. Seen here from left to right are (first row) Mary Dora Taylor Boyle, William Augustus Boyle Sr., "Aunt" Katherine ?, Leo Hansberry, Mary Boyle, Sallie Hansberry, and Reverend Dart; (second row) Nancy Cuttino, Jane McClellan, James "Bubsy" Boyle, "Aunt" LaLa ?, Polly Hansberry, Leo Hansberry, and Martha McClellan. (SJB.)

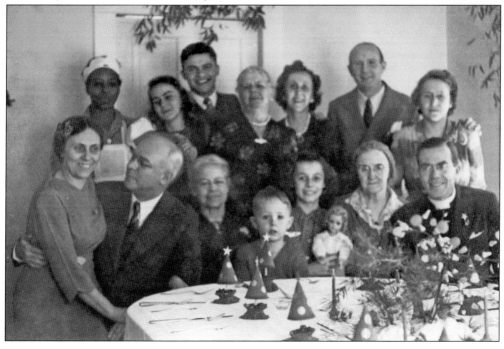

After World War II, the Clarence A. Dunning American Legion Post 21 at 105 Sumter Avenue built a memorial commemorating Summerville men who died in service. The post is named for the one soldier from Summerville who died in World War I. The engraving reads, "In memory of the dead of all wars. James W. Bazemore, Martin M. Lotz Jr., Paul K. Mellichamp, Nelson W. Moorefield, Henry W. Myers, Robert M. Spriggs, Edward R. Wheler." These men died serving in World War II. (MAM.)

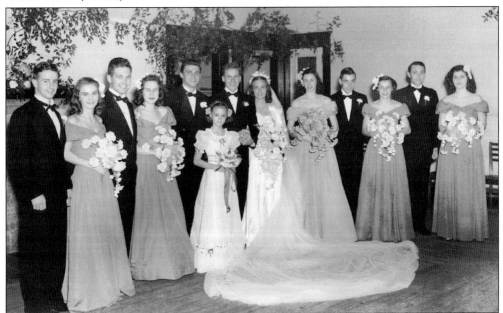

William Augustus Boyle Jr. returned safely from World War II and married Mary Hemphill in 1946. The reception was held at the Candlelight Inn at the Pinehurst Tea Farm. The wedding party included, from left to right, Meredith Jones, Jane McClellan, Robert Hemphill, Isabella Bailey, James "Bubsy" Boyle, Bee Robertson, Boyle, Mary Hemphill Boyle, Elaine Vincent Hemphill, Frank Cuthbert, Mary Boyle Limehouse, James Tupper, and Clara Waring. (SJB.)

In the summer of 1946, Bill McIntosh (right, center) was back from service in the Pacific. Here he is teeing off for 18 holes under the pines with his friends. Bill and Beth McIntosh (below) were photographed in their backyard at White Gables in 1947. Later, shocked by all the changes in the town during her brief six years living away, Beth became very involved in saving the natural environment, historic homes and buildings, and heritage of Summerville. In 1972, she founded the Summerville Preservation Society. She served on the Summerville Town Council chairing the Tree Committee; was a member of the Governor's Beautification Committee; and chaired Dorchester County's Historic Commission for the 1976 American Bicentennial celebration. A collection of her articles about historic town sites written for the *Summerville Journal Scene* was published after her death as *Beth's Pineland Village*. (Both AM.)

The azaleas were in full bloom when Beth McIntosh's mother, Gladys Gibbs Whitehurst of Richmond, Virginia, came to visit in the spring of 1948. Although the golden era of the Summerville inns had ended, the town's weather still attracted visitors from colder parts of the country. In April, when the azaleas were blossoming in Summerville, Richmond might still experience snowfall and ice storms. (AM.)

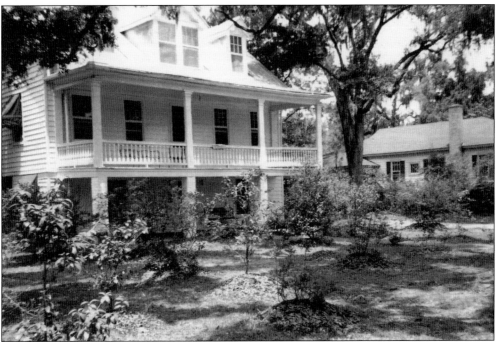

Mildred Giet grew up in this house, called Oak Haven by her family, on Sumter Avenue next to the Carolina Inn. Giet remembers that the stables located on the Oak Haven property were used by the inn. (MG.)

In 1951, the Boyle children played in the yard of their grandparents' home on Carolina Avenue. These children had quite a family lineage to live up to. Mary Barnwell Boyle was the fourth Mary in her mother's family line. Her father's mother and sister were also named Mary. To keep them straight, nicknames were required. Hers was "Sissue." (SJB.)

William Augustus "Gus" Boyle (left), Terry ? (center), and John Edward Frampton had fun on this old-fashioned whirly bird. Gus was the sixth William Augustus in his family. His son is named William Augustus, as is his grandson. Boyle's namesake ancestors include a Civil War officer and Charleston police commissioner, veterans of World War I and World War II, and an amateur golf champion. Gus served in Vietnam as a linguist in the U.S. Air Force. (SJB.)

In 1951, future Summerville High School Green Wave football players gathered on the field for an early training session. Other photographs from the occasion show Coach Harvey Kirkland comforting a crying player while the other boys try—some unsuccessfully—to sit still for the camera. (SJB.)

These local children dressed up for a Tom Thumb wedding in 1953. Some of their parents had performed as children in an earlier wedding held by the Winthrop Daughters at Summerville Town Hall. From left to right, shown here in the Prettymans' living room, are (first row) Mary "Sissue" Boyle, Franklin Smith, and Nancy Walker; (second row) Mark Meyers, Fleming Prettyman, Polly Walker, Warren Roberts, and Cheri Jones. (SJB.)

In 1954, summertime in Summerville meant T-shirts, shorts, sandals, and playing outside for hours. Two-year-old Edward Mazyck McIntosh played with his little red wagon in the backyard at White Gables. Formerly a resort inn run by McIntosh's grandmother, White Gables was the family home until 1986. William A. McIntosh; his wife, Beth; and their three sons—Brad, Edward, and Alexander—lived there. (AM.)

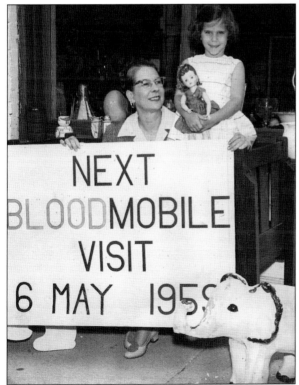

Mrs. Robert Hemphill (left) ran the White Elephant Shop on Central Avenue. She was also very involved with the Red Cross Blood Drive and donated almost every time the mobile unit came to town. In 1959, she and her granddaughter, Dora Taylor Boyle, promoted its next visit to the Summerville National Guard Armory. (SJB.)

Children growing up in downtown Summerville are lulled to sleep, awaken early, and listen throughout the day to the sound of the train. Even from a mile away, the train can be heard rumbling through town on a quiet night. It is no wonder many children become fascinated with them, building models and collecting train memorabilia. Alex McIntosh lived at White Gables with the train tracks just beyond the back gate. In 1962, he was photographed in his conductor's uniform on the porch. (AM.)

From the earliest days, Summerville has been known for its good hunting grounds. Gus Boyle (left) grew up hunting with his friend Caldwell Zimmerman. Boyle, Zimmerman, and Emerald (Gus's green truck) took the dogs out early on this day in 1964 to catch the sunrise and bag several rabbits. (SJB.)

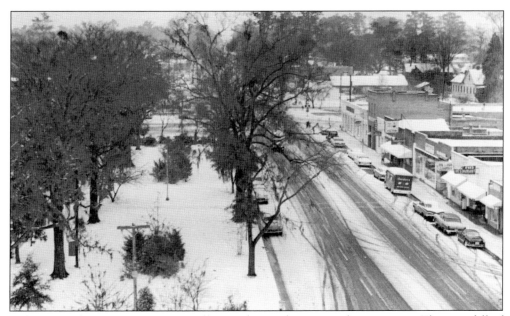

It does not often snow in Summerville, so when it does, it is a big occasion. The snowfall of 1966 was deep enough to coat the streets with a couple of inches. That year's Summerville High School yearbook memorialized the event with this photograph of Hutchinson Square and Main Street. (SJB.)

Christina Godfrey Tucker loved children. During the 1970s, she ran the nursery for Bethany United Methodist Church as well as its Friday Mother's Morning Out program. On Wednesdays, she kept the children for Mother's Morning at St. Paul's Church, and on the second Tuesday of each month, she oversaw the nursery at the Summerville Presbyterian Church. Here she is reading to (clockwise from bottom left) Walker Smith, Johnny Smith, Christine Godfrey (her granddaughter), Melissa Collins, and Will Collins. (SBG.)

For several decades, Bacon's Bridge was a gathering place for teenagers. They would jump or dive from the bridge, swing off a tree rope, climb onto the old dam (removed after Hurricane Hugo), or just hang out by the Ashley River. In horse-and-buggy days, it was a crossing to Dorchester, Orangeburg, and Augusta Roads. Later it became a popular picnic spot. Several stories circulate about the bridge's historical significance during the American Revolution. It was reportedly a resting spot for Francis "Swamp Fox" Marion and a favored location for American troops to camp since they could guard the bridge. American soldier Ralph Izard is said to have used Bacon's Bridge as a crossing to notify a Patriot cavalry regiment of nearby Loyalists after they finished searching Izard's plantation while his wife calmly kept him hidden in a clothespress. (Above, SDM; below, TIM.)

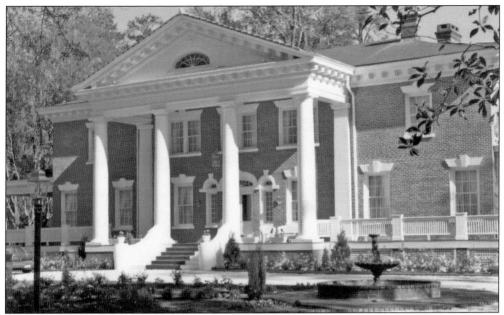

When Alain White died in 1951 with no heirs, he left Woodlands to his friend Ruth Gadsden. She lived there for the remainder of her life. Antonio and Debra Diz purchased Woodlands in 1985. They renovated and added rooms to make 14 total bedrooms with private baths. With renovations completed, there was a grand opening party for Gadsden Manor Inn on March 29, 1986. Helen Anderson Waring Tovey (below) did secretarial work for the Dizes a couple of days each week. During lunch, she started playing the piano in the dining room. The guests enjoyed it so much that the Dizes asked her to play every day. Tovey also attended many parties and dinners at the inn; she often played the piano with her second husband, Herman "Judge" Renneker Tovey, looking over her shoulder. (Both HAT.)

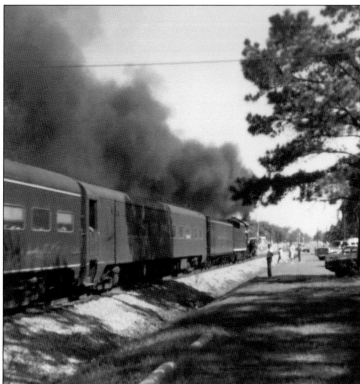

In 1832, the first railway to Summerville was operated by the South Carolina Canal and Railroad Company of Charleston. After a few organization and name changes in the 19th century, the line became part of today's Norfolk-Southern Railway. In about 1985, this weekend excursion train ran from Charleston through Summerville on its way to the Raylrode Daze Festivul [*sic*] in Branchville, South Carolina. Local train enthusiasts turned out to greet the locomotive. (AM.)

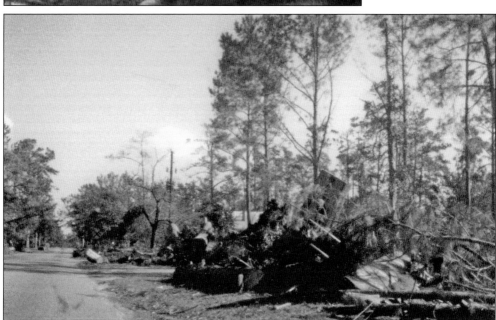

Summerville's worst natural disaster came on September 22, 1989, when Hurricane Hugo—classified as a category 4 storm by the National Hurricane Center—passed over the town with wind speeds of up to 135 miles per hour. The worst of the storm hit at midnight. The next day, debris was piled along the roadsides as crews cleared the streets and residents began to deal with the aftermath. (MG.)

Though no one in Summerville was killed, many of the town's homes, businesses, and churches sustained damage. With power lines broken by falling trees and debris, it took weeks to completely restore electricity. Initially, water was not safe to drink. The *Summerville Journal Scene* reported eight local homes destroyed, 459 substantially damaged, and 3,269 affected in some way. Dorchester was one of the counties hit hardest by Hugo; damages have been estimated as high as $750 million. (FP.)

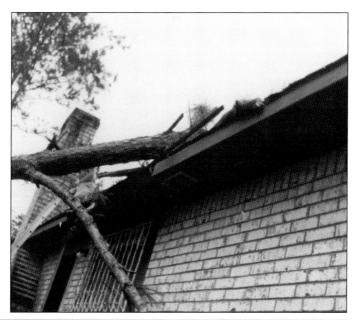

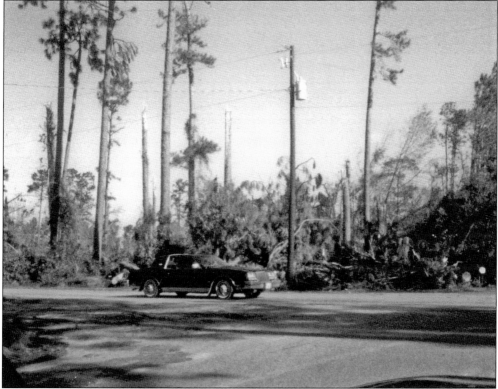

Many of Summerville's beloved pine trees were destroyed during Hugo. The falling trees and limbs caused damage to buildings and cars as well as utility lines. Some pines had been snapped off midway down their trunks like toothpicks. In the Azalea Park area, over 300 trees were downed. One of the first sounds heard on the morning of September 23—and for weeks to come—was the buzzing of chainsaws. (MG.)

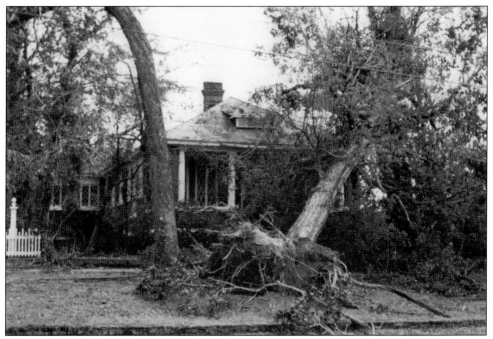

Some of the town's old oak trees were toppled by the storm, including this one at the Timrod Library. An emergency shelter was set up at the high school, and the town established a distribution center for clothing, food, and water. Pres. George H. W. Bush arrived to survey the damage, FEMA set up a disaster assistance center, and help was provided by individuals, churches, civic groups, businesses, and towns in the surrounding area—with donations arriving in Summerville from as far away as Connecticut and New Jersey. (TIM.)

A memorial was unveiled at the entrance to Azalea Park on September 22, 1992. The 125-pound black marble slab features an engraving of the state's outline with a depiction of the storm as the eye moved across Summerville. Commemorating the help that was provided in the following days, weeks, and months, the plaque reads, "Dedicated with abiding gratitude to the thousands of people who assisted us spiritually, physically and financially during the aftermath of Hurricane Hugo." (JC.)

Six

SUMMERVILLE TODAY

Growth has continued over the last decade; by 2005, Summerville had become South Carolina's third-fastest-growing city, with an estimated population of 35,000. Estimates for the 2010 census figures are over 45,000. The growth has occurred in sprawling residential developments on the outskirts of the downtown district, mostly in a southerly direction spreading closer to North Charleston, but also toward Berkeley County. Still, even with all those people living nearby, there are no high-rises or skyscrapers in Summerville. For the most part, it remains a single-family-home suburban area with 65.7-percent home ownership and an above-average median household income of approximately $44,000. Along with the population increase and the enlargement of the physical area due to annexations, the services provided by the town have grown. There are now 3 high schools, 6 middle schools, and 11 elementary schools. Approximately 70 percent of high school graduates enroll in post-secondary education. In 1998, *Kiplinger's Personal Finance Magazine* listed Summerville as one of their top six places to retire in the United States. Summerville has a mid-sized town population with a small-town feel.

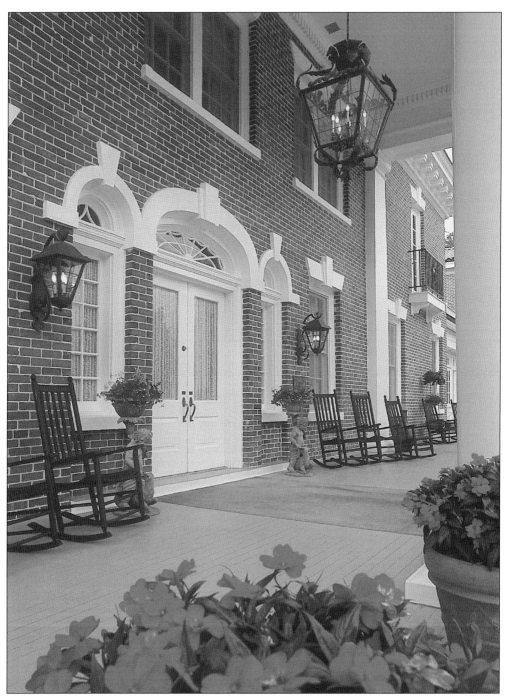

Built as a private family home around 1906 and remaining a single-family home for many years, the property at 125 Parsons Road operated as Gadsden Manor Inn for about five years, beginning in 1986. Then the house underwent further renovations under new ownership and opened in 1995 as Woodlands Inn, receiving its first AAA Five Diamond Award in 1997. In 2006, Woodlands Inn was purchased by Salamander Hospitality. Refurbishments included the addition of Pines, a casual dining option. (WI.)

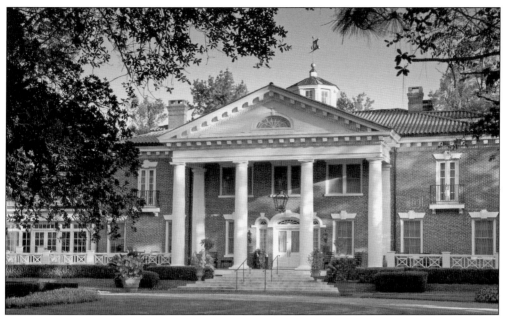

Woodlands Inn consistently places high in polls and rankings for American hospitality; it was recently voted the second best inn in the United States and Canada by *Travel and Leisure*. It is one of only four hotels in the United States to earn the Forbes Five Star Award and the AAA Five Diamond Award for both lodging and dining. In 2010, the Linton family—Summerville residents, 15-year club members, and longtime fans of the property—purchased the inn. One of their goals is to bring the Summerville community back to Woodlands. Specific plans include a culinary academy, an artist-in-residence, and showcasing performances and demonstrations by local musicians, artists, and craftspeople at the property. The new Artist's Palette program brings a local painter to the Sunday brunch each week. A neighboring bagpiper currently welcomes the weekend with a performance on the inn's front steps each Friday afternoon. The Lintons also plan to name each room after a famous South Carolinian. (Both WI.)

Barbara Lynch Hill is a columnist for the *Summerville Journal Scene* and a historian of Summerville. In 1992, she was hired by the town to record its story for the 1997 sesquicentennial. The resulting book was published in 1998 and is still available for sale at Summerville Town Hall. (MAM.)

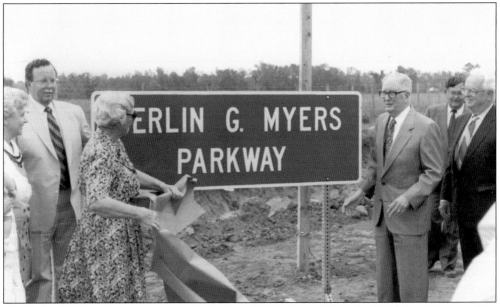

The Berlin G. Myers Parkway was unveiled in June 1998 by Janie Myers, the first lady of Summerville. Her husband started working on the project as a member of the town council in the 1970s. At present, plans for an extension to complete the bypass and further divert traffic from Main Street await funding and town council approval. Seen here from left to right are Betsy Myers, Rep. George Bailey, Janie Farmer Myers, Mayor Berlin G. Myers, unidentified, and Summerville town administrator Jack Wilbanks (MM.)

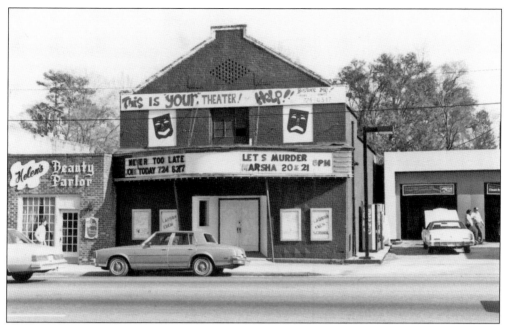

In 1987, the Flowertown Players launched a fundraising campaign for further restoration of the James F. Dean Theatre, named for a founding member. The volunteer group has been staging successful plays, reviews, and talent shows for over 30 years. Children's theater activities include shows for school groups and a summer theater workshop. *Driving Miss Daisy* is just one of the popular plays staged by the Flowertown Players. The 2000 production starred, from left to right, Todd Ashby as Boolie, Thayer Boswell as Miss Daisy, and Chuck Venning as Hoke. Other recent attractions have included *The Rocky Horror Picture Show, Cat on a Hot Tin Roof, Beauty and the Beast, The Somewhat True Tale of Robin Hood,* and *The Philadelphia Story.* (Both FP.)

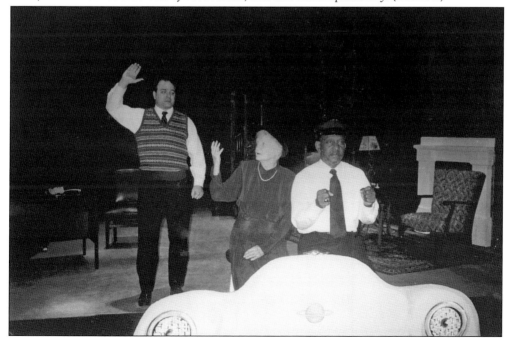

Since 1975, the Cuthbert Community Center has been located in the center of Azalea Park. Grange Simons Cuthbert was mayor from 1932 to 1947. He was a moving force behind the establishment of Azalea Park, which opened in 1935. (MAM.)

In 1975, after many years of neglect, Beth McIntosh took on restoration of Azalea Park as part of the bicentennial commemoration. Funding secured, the initial eight-acre phase took about four years to complete. Since then, further landscaping efforts and natural changes have occurred, including the felling of about 300 trees by Hurricane Hugo. Residents and visitors enjoy the park as home to the annual Summerville Family YMCA Flowertown Festival, Sculpture in the South, the occasional Summerville Community Orchestra performance, and private visits. (MAM.)

Sculpture in the South is a nonprofit dedicated to promoting sculpture through education and the selection process for the Summerville permanent collection. *Follow the Leader* was installed in Azalea Park in February 2002. It is the work of artist W. Stanley "Sandy" Proctor and was the show favorite in the annual Sculpture in the South Show and Sale in 2000. (SS.)

Sandy Proctor also created *Toby*. He was donated by Joann Brooks in celebration of her late husband, John. When John was ill, a yellow Labrador retriever adopted him. After John died, the dog he had named Toby went away. A few days later, Joann found Toby waiting for her. After spending the night, he walked around the house, looked up at her solemnly, and then left forever. Petting the statue of Toby on the head is rumored to bring good luck. (JC.)

The Garden sits quietly in Hutchinson Square. This life-sized bronze faces toward the new town hall as if facing the future with optimism. She is the 17th installation in the Sculpture in the South series. The artist, Susie Chisholm, is from Savannah. (SS.)

Tony Orlando and Dawn's "Tie a Yellow Ribbon 'Round the Ole Oak Tree," was popular in the 1970s. Since then, people have been tying ribbons around oaks to show support for loved ones who are away, especially those serving in the military. The yellow ribbons around the oaks at town hall and in Hutchinson Square now are for the soldiers in Iraq and Afghanistan and those stationed in foreign posts all over the world. (MAM.)

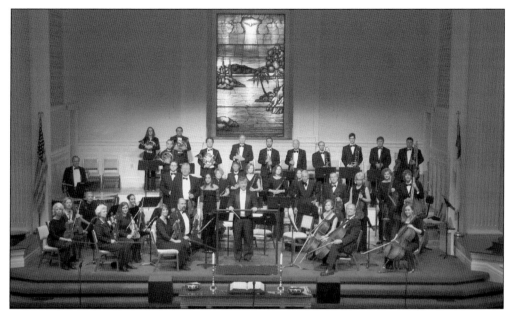

The Summerville Community Orchestra formed in 2003 and has been performing classical, pops, children's, jazz, and patriotic concerts since then at area churches and parks. The volunteer musicians are lead by conductor Alexander Agrest, who studied at Leningrad State Conservatory. By attending concerts and becoming active in the guild, orchestra enthusiasts can support the goal of enriching the cultural environment, entertaining and educating audiences, and providing opportunities for musicians of all ages and statures "to play for the pure joy of it." (SCO.)

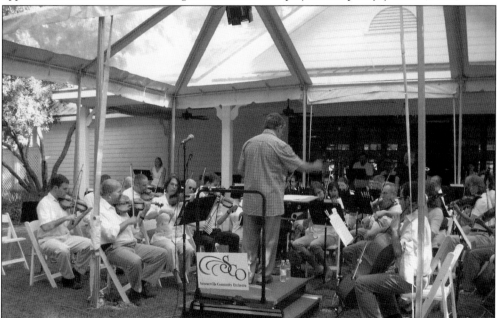

The Summerville Community Orchestra's most popular event is the annual fall concert held in Azalea Park. The audience brings lawn chairs, picnic blankets, and baskets to enjoy the music in the natural setting. Shows are also performed at St. John the Beloved Catholic Church, Summerville Baptist Church, and the outdoor amphitheater at the Ponds. (SCO.)

Summerville D.R.E.A.M. (Downtown Restoration, Enhancement, and Management) sponsors events in downtown Summerville like the annual Red, White, and Blue on the Green parade for the Fourth of July. Affiliated with Main Street South Carolina and the National Main Street Association, Summerville D.R.E.A.M. works to enhance community identity and pride by providing "hometown" events, assisting businesses with design improvements, building tourism, and marketing Historic Downtown Summerville to residents and guests. (DRM.)

D.R.E.A.M. is a nonprofit organization dedicated to improving the quality of life in Summerville. Events like Third Thursday bring residents and visitors to the downtown area with the hope they will return again on their own. A typical Third Thursday includes music, outdoor dining, an antique car show, an art walk on Short Central, booths from off-site merchants, special deals and special meals offered by downtown establishments, and dancing like this Shaggin' and Shoppin' in Downtown Summerville street dance. (DRM.)

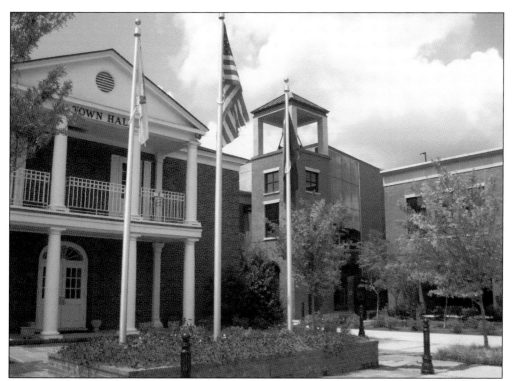

The Summerville Town Hall Annex was completed in 2005. The expansion provided space for retail shops as well as ample parking for the downtown area in an enclosed garage. (JC.)

This fountain behind the town hall was installed in the late 1970s as a replica of the Pres. Franklin D. Roosevelt Memorial Fountain in Warm Springs, Georgia. The plumbing and lighting were updated in 1994, and now the Farmer's Market is held next to the fountain during spring and summer months. The fountain and its surrounding small park are a memorial to fallen Summerville firefighter Robert M. Bunch. (JC.)

On March 1, 2007, Mayor Berlin G. Myers celebrated his 90th birthday with a big, open-to-all party at his lumber company on North Main Street. According to his second wife, Marlena (right), Berlin views his biggest accomplishment as keeping the "village" in Summerville—keeping it clean and having a small-town feel even as the town's boundaries and population have expanded. (MM.)

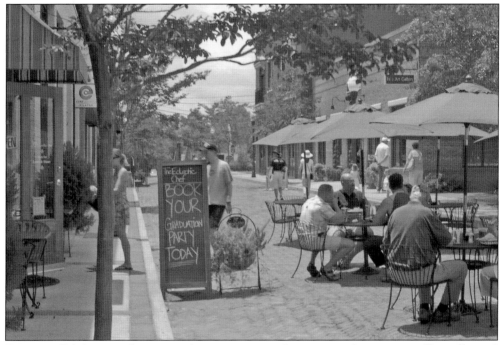

Summerville's historic downtown district is a nice place to spend some time. Short Central establishments have umbrella-shaded tables, there are sidewalk art shows, knit and chat events, theater productions, an art gallery, and boutiques selling unique gifts, decor, clothing, antiques, jewelry, and collectibles. Most of the establishments are locally owned and family-operated. (MS.)

Children may not be able to watch the Coca-Cola bottles running the conveyor belt at the bottling plant on Cedar Street any longer, but they can still enjoy a cold cherry Coke at Guerin's. Residents can still get a haircut at an old-fashioned Main Street barbershop. And visitors can settle into one of the rocking chairs along Richardson Avenue to take in the sights. Summerville is as great a place to live as it is to visit and as great a place to visit as it is to live. (WI.)

BIBLIOGRAPHY

Bell, Bernice, David Bell, Dan Murray, Janie Myers, and Ollie Smith. *Being Found Faithful: A Centennial History of Summerville Baptist Church*. Columbia, SC: The R. L. Bryan Company, 1995.

Bell, Daniel J. *Old Dorchester State Park Visitor's Guide*. Mount Pleasant, SC: South Carolina Department of Parks, Recreation and Tourism State Park System, 1995.

Chibbaro, Anthony. Images of America: *South Carolina's Lowcountry*. Charleston, SC: Arcadia Publishing, 1999.

Collins, Bill. *Reflections of Dorchester County, South Carolina*. Marceline, MO: D-Books Publishing, Incorporated, 2002.

Côté, Richard N. *City of Heroes: The Great Charleston Earthquake of 1886*. Mt. Pleasant, SC: Corinthian Books, 2006.

Deas, Anne Simons. *Points of Colonial Interest Around Summerville*. Summerville, SC: S. P. Driggers Print, 1905.

Dorchester Tricentennial Commission. *Days of Dorchester*. Summerville, SC: Dorchester County Historical Society, 1970.

Foster, Clarice and Lang, ed. *Beth's Pineland Village*. Summerville, SC: The Summerville Preservation Society, 1988.

Hill, Barbara Lynch. *Summerville: A Sesquicentennial Edition of the History of The Flower Town in the Pines*. Summerville, SC: The Town of Summerville, 1998.

Jamison, Elizabeth M. *Summerville Past and Present*. Summerville, SC: 1939.

Koets, Eleanor Brownlee, Margaret Scott Kwist, and Virginia Cuthbert Wilder. *Porch Rocker Recollections of Summerville, South Carolina*. Summerville, SC: Linwood Press, Inc., 1980.

Patrick, Barbara. "The Times of Our Lives: Celebrating the Azalea." *Summerville Newcomers Directory* (2010–2011): 10–13.

Walker, Legaré. *A Sketch of the Town of Summerville, South Carolina*. Summerville, SC: 1910.

Walsh, Norman Sinkler. *Plantations, Pineland Villages, Pinopolis and Its People*. Virginia Beach, VA: The Donning Company Publishers, 2006.

Zeirden, Calhoun, and Debi Hacker-Norton. *Archdale Hall Investigations of a Lowcountry Plantation*. Columbia, SC: Chicora Foundation Incorporated, 1985.

In the summer of 2003, the *c.* 1902 Garden House, also called the J. Gould Day House Gazebo, was moved from 409 Central Avenue to the garden at the Summerville Dorchester Museum. The small, enclosed building is of heart-pine with a door, two windows, wooden shutters, and a fireplace with mantle. When fully restored, the Garden House and surrounding garden will be a pleasant addition to Summerville's beautiful downtown. (SCA.)

SUMMERVILLE DORCHESTER MUSEUM

The Summerville Dorchester Museum is a 501(c)(3) educational organization dedicated to preserving the historical significance of Summerville and Dorchester County. Its mission is to collect, preserve, and exhibit artifacts and to develop educational programs relating to the cultural and natural history of the Summerville and Dorchester County area.

With a permanent collection that includes fossils and Native American artifacts, the Summerville Dorchester Museum is currently housed in a 2,300-square-foot historically significant building. Information on Summerville's historic inns is presented through interesting exhibits and panel displays. Educational exhibits on natural history and several important Revolutionary War period artifacts are also on display. Visitors can enjoy the many old photographs included in a wide variety of museum exhibits. A large collection of blueprints donated by the Summerville Water Department and the Legaré Walker land deed/mortgage file collections are available to researchers. Programs and special events are held annually for members of the museum and the public. The Summerville Dorchester Museum truly is a window to the past and contributes to the unique quality of life found in Summerville and in Dorchester County."

Summerville Dorchester Museum
100 East Doty Avenue
PO Box 1873
Summerville, SC, 29484
(843) 875-9666
summervilledorchestermuseum@gmail.com

DISCOVER THOUSANDS OF LOCAL HISTORY BOOKS FEATURING MILLIONS OF VINTAGE IMAGES

Arcadia Publishing, the leading local history publisher in the United States, is committed to making history accessible and meaningful through publishing books that celebrate and preserve the heritage of America's people and places.

Find more books like this at
www.arcadiapublishing.com

Search for your hometown history, your old stomping grounds, and even your favorite sports team.